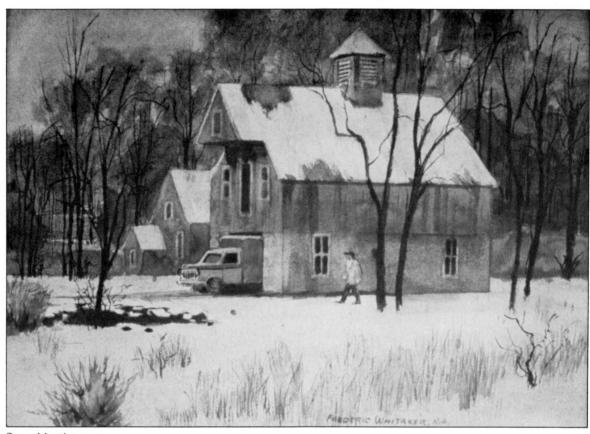

Snow Mantle
16 x 22 inches

The Artist and the Real World

by FREDERIC WHITAKER

North Light Publishers
37 Franklin Street • Westport, Connecticut

Published by NORTH LIGHT PUBLISHERS, a division
of FLETCHER ART SERVICES, INC., 37 Franklin
Street, Westport, Conn. 06880.

Distributed to the trade by Van Nostrand Reinhold
Company, a division of Litton Educational Publishing,
Inc., 135 West 50th Street, New York, N.Y. 10020.

Manufactured in U.S.A.
First Printing 1980

Whitaker, Frederic.
 The Artist and the Real World

 1. Art—Appreciation I. Title
Library of Congress Card Number 80–13616
ISBN 0–89134–030–0

Edited by Fritz Henning
Designed by David Robbins
Composed in Stymie Light by Stet/Shields
Printed and bound by The Book Press
Color Printed by Federated Lithographers

Table of contents

PART TWO
Art in Society

Color Portfolio
129

My sincere thanks to my fellow
artists and friends, Dr. Roy Paul
Madsen and his wife, Barbara, and
to my wife, Eileen, for their
having compiled and edited this
collection of essays.

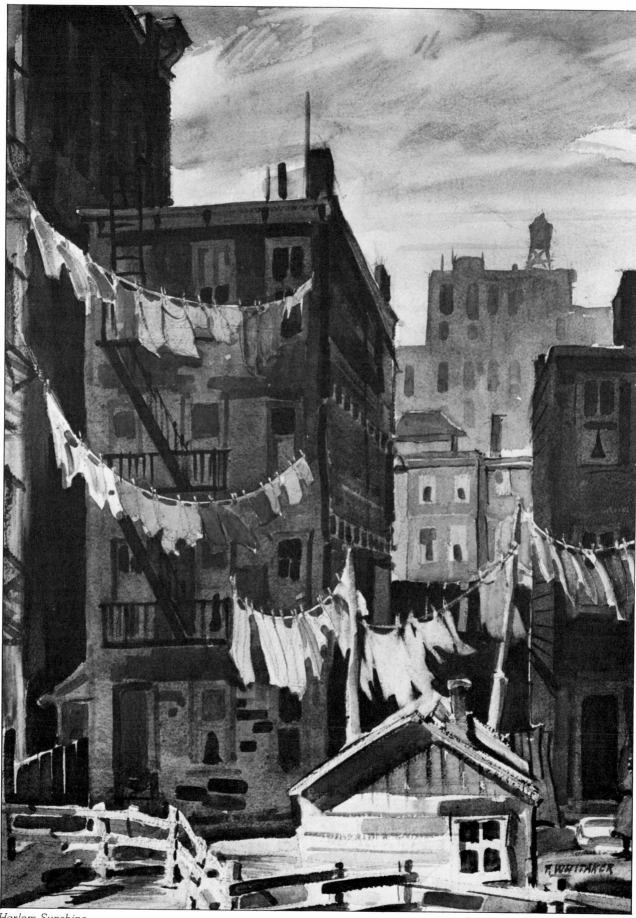

Harlem Sunshine

Collection of Mr. & Mrs. John Sands
Glendale, Arizona

Introduction

"Many are called, but few are chosen" was an observation made years ago about the great numbers of persons who wish to become artists and live the Art Life, but whose dreams wither in the trying. True, many would-be artists fall short for want of talent, training or the grit needed to succeed in any difficult enterprise. Many fail, however, because they get lost and cannot find their way through the crazy labyrinth of contemporary art in America. This book was written by a man, Frederic Whitaker, who trod a path to the top and wishes to pass on the benefits of his experience to those readers who dream of living the Art Life.

To know the story of Frederic Whitaker is like reading the biographies of three distinguished and successful men—entrepreneur, artist, author—encapsulated into one fruitful life. Born into extreme poverty, the man who became "Mr. Watercolor" was, from his earliest years, drawn to art. Apprenticed at fourteen to a metalware designing manufacturer, he began immediately to render the forms of new religious artifacts in the medium of aquarelle, a beginning which gave him the knowledge to become a successful manufacturer of religious articles and the skills to become one of the nation's preeminent watercolorists.

During these busy and even frenetic years of being an artist, writing about art and artists, and living the Art Life in New York, he began to jot down brief notes and essays which were intended only to crystalize his own thoughts about what it takes to become an artist in America. Never intended for publication, most of these collated essays are an incredible distillation of insight, wisdom and provocative thought about the uphill fight of becoming a figurative artist in an art world dominated by non-objective art. He offers astute perceptions of the politics of art and the manipulation of juries and art shows by well-organized minorities; the museum directors who control the forms of art allowed public expression; the role of critics who run in tight little ideological packs; the exclusion of the American people from any influence over the kinds of art forms supported by their tax dollars; and above all, he offers help to those sincere artists who wish only to live as artists.

These thoughts about "making it in Art" are like Frederic Whitaker himself: lucid and tough-minded, gentle and humorous, insightful, frequently tongue-in-cheek, usually profound, sometimes ascerbic, and refreshingly honest and intelligent. This book is a treasure trove of knowledge and experience about the art scene in America, and as such should find its way into the minds and libraries of every person who wants to live the Art Life.

Roy Paul Madsen

Dr. Madsen earned his Ph.D. in Communications from the University of Southern California. Currently he is a Professor, Department of Telecommunications and Film, San Diego State University. Besides teaching he is an artist, filmmaker, author and art consultant/advisor to a number of government agencies and large corporations.

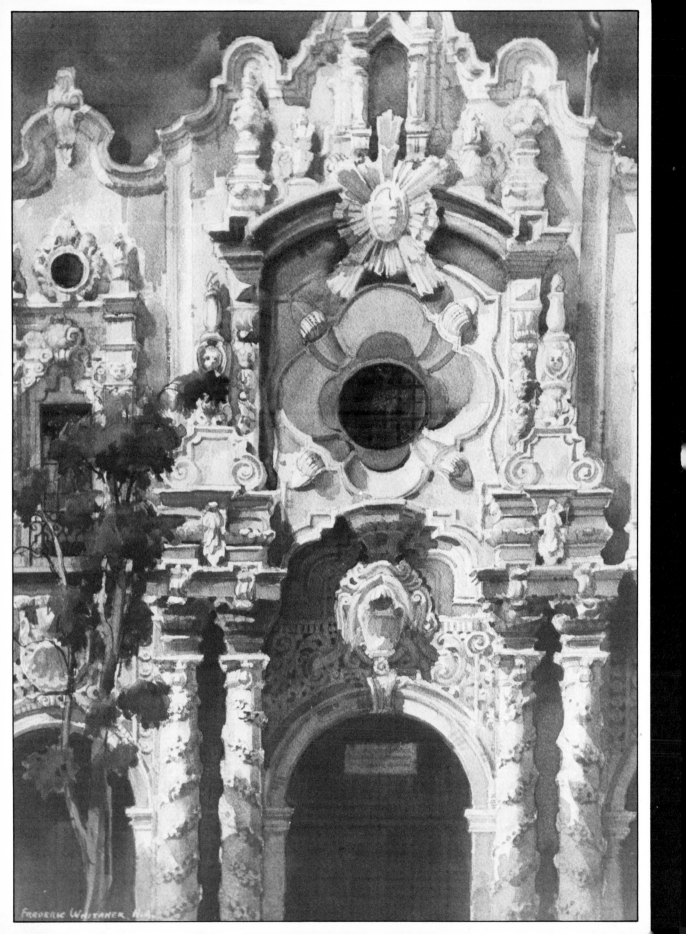

FREDERIC WHITAKER N.A.

Professionalism and Technique

Are You a Genius?

Every real artist is a genius. If one is not a genius on at least a modest scale, he will never become a real artist.

The outstanding characteristic of a genius is imagination, but so is it also the outstanding characteristic of a paranoiac. The borderline between insanity and genius is very thin, but there IS a difference. Insanity is imagination without control. Genius is imagination under control—plus the divine spark that we call driving force. Its possessor feels impelled to do certain things, to create something or to pursue a certain thought, despite discomfort and pain, despite obstacles, the importuning of friends or the opposition of enemies. This urge cannot be explained, nor can it be resisted, if one is a genius. Very few have it, and those who lack it can never understand it in others. That is one reason why the genius is often lonesome. He has to build a wall about himself to protect him from his friends and their schemes to use his time. In this way only can he follow his urge—this urge that cannot be ignored.

The appreciation of the value of time and his refusal to waste it is definitely a mark of the genius. In a year we have 8,760 hours. Of this we put in 2,920 hours in sleep, and at forty hours a week our regular vocations consume only 2,000 hours per annum—leaving 3,840 hours, nearly twice as much time as we give our employers, or a daily average of 10 and a half hours for each one of the 365 days in the year for our personal purposes. The use to which this latter time is put has something to do with one's genius, or at least his success. Most of us waste the greater part of it, but the genius makes sure that most of it is used in the advancement of his plans—artistic we hope.

From a materialistic view point, there is no sensible reason why one should become an artist. The average artist's income is undoubtedly less than that of the common laborer—and Lord knows there are many other discouragements and few rewards for the average follower of the artistic muse other than the joy of just being a creator. The answer is that an artist becomes an artist because he can't help himself. He never forgets his goal. As often as he is deflected from his course by people or cir-cumstances, he returns to the rhumb line when the retarding influence is removed. He eschews friends and pleasures when necessary, gives up his pelf for art material, paints and draws at every opportunity, and in divers other ways demonstrates that he is a completely unreasonable or irrational animal. Yes, it's a thankless routine, but if one hasn't a like urge in some degree he is not a genius and will never become a great artist.

So unless one is satisfied to become simply a capable painter, he'd better call it off now and leave the track clear for someone who CAN run.

What is Art?

To discuss anything sensibly the participants must be in agreement on the meaning of the terms used.

This explains the futility of trying to discuss art today. To quote a widely accepted definition, art is anything you want to call art.

If one thinks that four means four and his opposite number thinks four means twenty one, there is no point in discussing business. If one thinks digging a grave is art—as was proclaimed a while ago—and the other thinks of art as a Michelangelo production, the two are wasting their time in trying to converse.

Certainly today many things are called art which would not have been so described prior to the Armory Show in 1913 that began the "modern art" period in this country. And certainly many of the things designated as art today could be listed under *any* generic heading only with the greatest stretch of the imagination. Surely it would be difficult to think of a classification heading that could honestly include the aforementioned work by Michelangelo and an example of the new "conceptual art". If we insist in calling both "art" then we must accept as reasonable the statement that *"Art is anything you want to call art"*. If we do accept that as reasonable we must also agree that a house, a dog, a locomotive or anything else is anything you want to call it. This way lies madness.

There can be no objection to anyone pursuing any one of the many current forms of "art", but might it not be a good idea, when inventing a new departure, to invent, along with it a new classification name? Let us use as flattering a designation as we wish—but let it be something other that "art".

To couple some of the endeavors now masquerading as art with production that used to be called art is plain dishonesty.

"Visual" Arts

The art of drawing, painting, sculpture and design in general is translated to our understanding through the *eye,* as the art of music is revealed to us by the ear, the culinary arts by our tastebuds and the like. Each of these arts is able to speak for itself, conveying its message without verbal explanation.

However, many of the forms of so-called art, including "conceptual art", "performance" art and the like mean absolutely nothing unless accompanied by vocal and written interpretations. In other words they might be said to function only as subjects for conversation or polemics. This has nothing to do with the appeal to the eye and should not be included in the "visual arts".

The Purpose of Art

Listen to a dozen sincere speakers on the art situation and you will hear that many different opinions on its meaning. There is so little mutual understanding at times that it becomes virtually impossible for one to convey ideas by mere words. It is as though each disputant speaks a different language.

Analysis shows that the confusion prevails because there is now no agreement on the purpose of art—so without such agreement or understanding discussion is nearly futile.

Until the time of the "Ism" painters the purpose of art was reasonably well agreed upon by all. Today only those "know" its purpose who have been brainwashed by the art hierarchy.

According to one authority, the artist's chief obligation must be that of finding new and ever more new modes of expression; another may believe, with Diego Rivera, that "Art is propaganda or it is not art"; while the next may feel that the

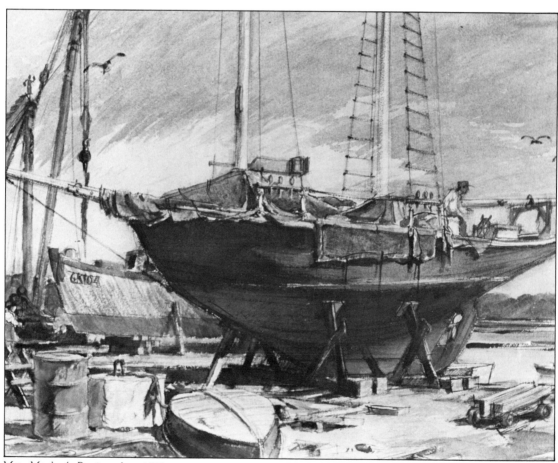

Mrs. Morley's Boatyard 1953

aim of art is to edify and entertain the beholder. The first ignores the lay viewer completely and considers only the interests of the *makers* of pictures; the second is not even concerned with art, as art; while the third interests himself principally with the feelings of the *users* of pictures. How can such divergent opinions ever be reconciled? How can their statements, based on such beliefs, be understood by others?

Of course the answer is that they cannot; nor is it necessarily desirable that they should, but it is desirable that a speaker explain his credo in advance to give meaning to his utterances.

All polemicists agree that the fundamental requirement for mutual understanding, in discussion, is a definition of terms or agreement on their meaning.

In my opinion the justifiable function of art is contained within three requirements, namely:

 1 Art must convey visual enjoyment to the beholder, in a distinctive way, or

 2 It must tell a story or communicate a worthwhile idea or message and by the power of its execution make that message memorable, or

 3 It must produce results that will later facilitate the provision of one or both of the desiderata listed above.

In brief, all art must convey something to the beholder. That the artist simply "expresses" himself is not enough. Art that *expresses* but does not *convey* is no art at all. It is of no more importance than the chirping of a cricket or the baying of a hound at full moon. Messages are for the receiver—always! What rational being ever concocts messages for his own edification? Or if he does, what right has he to expect others to spend time in considering them? Even though messages *are* designed for others they have no value unless someone is interested in their content.

No art can be successful unless it takes the public into its confidence. Art is not for aesthetes alone, nor for those who speak of it in esoteric terms. There is nothing sacred about art, and it must be judged by the same general standards that govern other human activities. Art that cannot explain itself had better be left undone. If verbal interpretation is required, why not simply frame the interpretation and dispense with the painting, for in any communication only the translation has value. Art should be discussed less and enjoyed more—and it should be enjoyed without the interference of explainers.

Creativity Is Not Easy

Thoughts, when being formulated, do not run in straight lines. They expand rapidly after a theme comes under consideration, like a rabbit's multiplication table, or the limbs, branches, and twigs of a tree.

A writer or public speaker has to rummage about, mentally, among these offshoots and select only those that help carry the main theme along, arranging them in fluent order so that the reader or listener gets a simplified and easily understood message. He, if he is an average person, will suppose that the delivered message came directly from the author's mind in that order.

Nothing can be further from the truth. To sit down with a recording tape and dictate a novel into it, from start to finish, without hesitation, would be as inconceivable as to paint an important picture by starting at the upper left hand corner of the canvas and painting across and down in finished detail, through to completion at the lower right hand corner.

A painter starts, usually, with a pilot sketch, to arrange the great shapes and colors until he has a balanced pattern or design before him. He then begins to convert these masses into understandable expressions, then continues with corrections of the corrections to achieve a dramatic effect, balance of colors and the like, and then adds the final details that give sparkle to the production. All this entails transposing, erasing and adding and the like. The viewer of the final work is seldom conscious of the enormous amount of exhausting mental concentration that has brought the creation to pass.

The essence of art ability is to give the impression, to the recipient, that the whole has been achieved without effort.

Writers and public speakers achieve their creative ends in the same general way as the painter, using words for their medium, rather that paint. The rules of composition are about the same for any form of expression, regardless of the medium.

No one can produce, without great effort, important creations that appear to flow easily from the tongue, pen or brush.

Design in Painting

Design, and "realistic" or representational painting, are two entirely separate branches of art. Many painters, of the realistic school, give little thought to design and profess little admiration for abstractionism, but reflection indicates they could profitably take a cue from their non-realist fellow artists and decide to incorporate more design in their pictures. All great paintings are well designed. Design is as important to a realistic painting as to a non-objective or abstract painting.

True, design is only one of the several qualities combined in a good representational picture, but it is just as necessary as the others—those others being: (1) three-dimensionalism or the implication of distance, (2) atmosphere, and (3) a "storytelling" capability or the suggestion of a recognizable thing or event.

It may be true, as some aver, that the abstractionist, having eschewed these qualities and having decided to proceed with only one string to his bow (namely design), finds it difficult to compete against his more literal minded adversaries whose pictures include, in addition to design, these other qualities so dear to the general public—but even if true, that should not deter us from grasping all the knowledge the abstractionist is able to give us.

In a way, composition *is* design, but that which we think of when we mention design is something more tangible and assertive. Design, as we know, is a conventional, symbolic, representational, or just arbitrary arrangement of forms, lines, colors, etc., arranged to please the visual sense and without necessarily suggesting things or events such as shown in realistic renderings.

A design is a pattern, deliberately thought out. An abstract painting is a pattern of shapes, colors, textures and directions—nothing more. A good representational painting is also a pattern of shapes, colors, textures and directions, plus a likeness of an identifiable something. The *pattern* in the latter picture should have received as much attention as that in the abstraction.

In my own representational work, I try to achieve design by deciding in advance just what sort of pattern is suggested by the scene before me. I decide upon a number of spots, shapes or directions arranged in balance over the expanse of the paper in various hues and depths of color. These spots, colors and directions, though suggested by the scene, have no bearing on its realistic aspect, but are arranged solely to provide visual enjoyment. This considered arrangement is my pattern, and I follow it faithfully. Though the realistic characteristics do fully assert themselves in my finished work, they will be found, upon inspection, to be subordinate to the plan of spots, colors and directions decided upon. Regardless of the detail within the spots or areas themselves, the areas are definitely there when the picture is finished—or so I like to persuade myself. As each spot is painted, the detail within it is deliberately restrained so that that detail is never more apparent than the spot itself.

To explain the matter in reverse—take virtually any good realistic painting and with a little imagination reduce it to a pattern of shapes and colors that in themselves have no meaning. But it will be observed that those shapes and colors

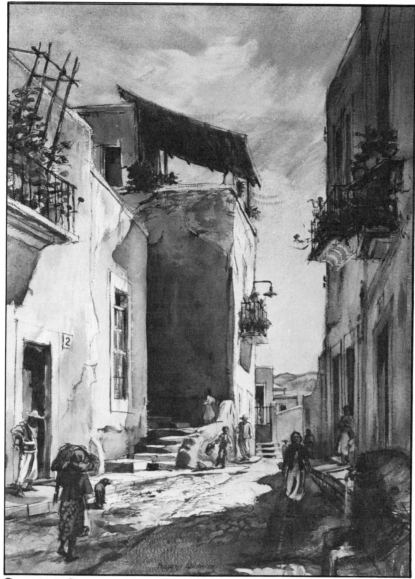

Guanajuato Street
22 x 30 inches 1950

in combination will balance well and will provide a good abstract design.

Certainly there is more than this to design in painting, but if we will follow the connotations and ramifications of the one thought discussed above, we shall be well on the way toward the goal of more and better design in our paintings.

What Is A Composition?

Art instructors frequently emphasize the contention that a pictorial work of art must be a complete "composition".

This brings out the query, "What is a composition? Isn't any picture a composition?"

The answer is no. For example, a photograph of any scene is a picture, but unless the photographer who snaps it is extraordinarily skillful, artistically, it could not be a composition. A representation simply of a lot of things is not a composition. A composition must be calculated. It does not come about by chance.

A perfect composition is a complete, self-sufficient entity. Within its borders are found everything that it requires and nothing that would fail to help it. The slightest change, addition, or subtraction would sully its perfection.

It must tell its story and hold the viewer's attention by reasonable persuasion, leading it from point to point without his knowledge that he is being led. This composition must have a center of interest, and one only. All other features are secondary to the main feature. It must have "repose", which means that every element stays in its own place and does not vie with others. The focal point is not so insistent that ones eyes become glued to it. The arrangement is so designed that the eye instinctively, or unconsciously, arrives at the focal point, then meanders about through various interesting areas and eventually comes back again to the focal point, to start out again on another similar journey. At no time is the eye persuaded or permitted to leave the picture completely—and this is not accidental, but is due to the excellence of the pattern.

Composition is largely a matter of balance—balance of color, of values, of bulk, and of directions.

As previously stated, these combinations do not arrive fortuitously. They appear only as the result of skill and knowledge. But every picture claiming to be a work of art must be a complete composition—not just a representation of a scene.

Every picture painting has three main attributes: conception, mood, and composition. *Conception* refers to the thought behind the work; *mood,* to the key or atmosphere in which it is developed; and *composition,* to the technical arrangement of parts. Unless the composition is correct and sound, no amount of clever drawing, brushwork, or coloration can make a good picture of it.

Content and Composition

Most individuals, including many who call themselves artists, feel the purpose of painting is simply to register on paper or canvas a recognizable likeness of the thing before them and that, this accomplished, both painter and painting are successful.

These people seem to look upon drawing and painting as a sort of stunt, in which the "artist" vies with the camera to demonstrate his cleverness. Often we hear the expression "That painting is almost as real as a photograph." So let us get this point established—the aim of the artist is *not* to reproduce what he sees. Why should a man spend hours making a copy the hard way when the camera can do it better in a flash?

The real mission of the artist is to produce a masterly composition—an arrangement of colors, forms, and other ingredients in perfect balance and harmony with each other and in which no necessary component is lacking and no useless detail is included. Making a painting is like writing a novel or producing any other creative work. Read a conversation in a novel and you will notice the characters say only the words necessary to carry the plot along. In the book the conversation seems perfectly natural, though we all know that when people talk in actual life their remarks are not so well organized. They talk all over and around a subject and they include many unimportant references. The author has to reduce the rambling discussion to its essence, and for this he may require only a few short sentences. When a musician composes a "pastorale" he doesn't attempt to duplicate the actual bleating of the sheep or the clanking of the cowbells, but he often does contrive a diverting concert piece that hints at rustic tranquility.

The artist's problem is the same. If you will look at a certain stretch of the countryside you may find its appearance pleasing, but unless you are an artist you probably will not dissect it visually to ascertain what makes it pleasing. You just accept it as beautiful. If you were an amateur painter you would strive to capture that beauty by painting into your picture everything visible. But actually that scene may be beautiful because of only a few simple factors. The great majority of the details are superfluous. The contrast of white houses against a red barn, with golden wheat in the foreground, lavender hills in the distance, and a grey sky are material enough for a masterpiece of painting. Carrying this simplification still further, the painting could be almost as attractive if these ingredients were set down as just so much color, without necessarily identifying the white spots as houses or the red one as a barn. Those color spots, and their arrangement, are the *essence* of the picture, and anything else added is of subordinate importance.

In the actual outdoor scene there are necessarily thousands of other details present: rocks, tree branches, telegraph poles and what not, but as they are not essential to the beauty of this particular picture, the accomplished artist leaves them out. Then it may be that in actuality there are no lavender hills in the distance, but as the painter feels the note is necessary for his composition he adds them. To repeat: a good work of art excludes everything not needed in the telling of the story and includes everything requisite. A finished composition balances perfectly. Any new item added or anything taken away would detract from its perfection. True, the picture appears perfectly natural and one may imagine it is a lifelike representation of some actual scene in its entirety, as one, reading a novel, never misses the irrelevant idle chatter which the author has skillfully eliminated.

Whether or not the artist's finished painting resembles the scene before him is unimportant. He simply uses the scene as a foundation for his theme and then adds, subtracts or changes as he deems wise.

True, the accomplished artist often can choose a scene that is *nearly* perfect, so he need not change it greatly, but actually there is no perfect composition in nature. The ingredients may be there but never in the correct order. That is why a photograph can seldom compare with a good painting as a work of art. The camera cannot *compose,* and for that reason the artist will always be necessary.

Technique

When I was 15, I subscribed to a correspondence school art course. At that time, correspondence schools were active in great numbers.

Through the course I got to know many other art students who spent much time in discussion of art subjects. They took their study seriously and they attached much importance to the theories of the day.

One subject that was rated as very important was that of "technique", meaning an artist's personal style of painting or drawing. Students who were mere beginners felt that a personal "style" could, at a mere glance, separate their work from that of all other artists. They all wanted "recognition"—effortless recognition—which is quite a big wish!

The result was that in many cases their art product was little more than gimmickry. In other words, this particular phase of art production was much like the striving of many of the "far-out" artists of today.

As all successful artists have learned, you can't successfully acquire a personal "style" simply by being different. You

have simply to work toward *better* paintings—better and better—without thinking about a personal "technique." A Style will eventually manifest itself, so that the art authorities will recognize it instantly. But don't think that can be achieved in a year. It takes much time and effort to become a successful artist, but you will have the satisfaction of knowing that your "technique" or "signature" is an honest one. You can attract attention by wearing a pink derby, but that type of attention will brand you as a "nut," instead of a real artist.

Quick Sketches Versus Finished Compositions

At some point in their careers, all serious students—whether of watercolors or anything else—are shocked to find that they must unlearn a great part of the things they have been taught to accept as gospel. Most "information" is incorrect—in whole or in part. The sooner in life we learn this truth the sooner we achieve tolerance, for we become less exacting toward our fellows.

In this business of accepting "truths" that are false, the teaching profession seems particularly gullible and inordinately inclined to espouse untried theories that must later be discarded. In the field of watercolor a great harm was done years ago by emphasis on the supposed fact that watercolor paintings, to be successful, must be executed in a brief time—thirty minutes to an hour being the customarily estimated period.

I have often felt that I could have painted as well as I do now years ago, except for that hurry-up indoctrination. A friend of mine died recently at sixty-five. He was a successful and remarkably skillful pen-and-ink draftsman. But, though he tried incessantly, he never succeeded as a watercolorist—because he allowed himself but a half hour for each attempt.

Please remember, I am not opposed to quick sketches. But this longstanding dogma calls for quick sketches *exclusively,* and to that I *am* opposed. The quickly rendered watercolor has its place, and an important place, but it is not *all* of watercolor. The serious, finished composition is even more important.

But for this speed fallacy, American watercolorists as a class might have realized in 1920, as they do now, that watercolor is not simply a "shorthand" medium, but that it can hold

its own with oil and other mediums in the production of serious compositions, of pictures that are designed to stand the test of time. These serious compositions cannot be achieved hurriedly. Composition in any medium requires careful planning. The difficulty in watercolor is even greater, for while all the designing skill that goes into an important oil is called for, there is the added requirement that the freshness and apparent spontaneity usually associated with aquarelles be retained.

Perhaps the fact most commonly noted by jurors, when judging watercolors, is that the works combine excellent brushwork with poor composition. Many prize-winning pictures are poor in design, but the judges have overlooked that weakness because of the virtuosity of the handling and because, especially, of the widely-accepted theory that cleverness is as much as one can expect in watercolor—"which," they say, "necessarily must be done quickly."

Always there is the necessity for improvement of all parts of a painting composition down to the smallest detail. Let me admonish you against the misconception regarding haste. In painting anything is *Take it easy. Don't hurry.*

Let's remember that "Genius is a capacity for taking pains". Let's remember that our paintings are going to last longer than we are, and that, when they are judged later, we'll get no credit for having saved an hour or so in the work. The critics won't say, "That is a good painting, for a three hour job." They'll say it's a good work, period, or it is not a good work, period. We ourselves should judge our pictures similarly. Quality is the only thing that counts. Time doesn't matter. We are trying to paint, not to astonish our friends with lightning-fast sleight-of-hand tricks. As long as any part of a picture can be improved, it is not finished—and by improving, I do not necessarily mean polishing or detailing. A dashing effect can remain a dashing effect—but it is not necessarily achieved by dashing.

On the other hand, the avoidance of haste does not grant the privilege to dawdle. To be quick does not mean to get excited, and to take your time does not mean to waste it. The master never hurries. He is thorough in his work, but he gets things done with surprising expedition—and he accomplishes this by eliminating all useless action, mental or physical.

Build your compositions carefully. This business of attempting to turn out finished creations in a few minutes, of over-simplication, and of painting a picture with six swishes of the brush, is just so much rot. Waste as little time as possible, but regardless of time, DO IT RIGHT.

How I Paint A Watercolor

One is not an author when he has learned penmanship, nor is a painter an artist because he can apply color. In any field, after technical competence is achieved and the resultant glow of satisfaction has subsided, the student realizes he has mastered a means of expression and not an art; but from his new vantage point he can survey that field, grasp its implications and sense its possibilities. The art fraternity, collectively, is in this position with regard to watercolor. As used today, watercolor is a relatively new medium, and its potentialities are just being realized.

The aforementioned fact, fixed firmly in mind, has changed my style of painting considerably during the past several years. I seem to have removed myself from that group which looks upon watercolor as a "half-hour medium"—which insists that aquarelles be completed quickly in a blaze of brilliant brushwork. We all go through that stage, but I for one am convinced, more and more, that an important composition in the aqueous medium calls for as much thought and effort as a comparable work in oil. In its relatively new role of self-sufficient medium—The American Medium—watercolor finds that technical excellence alone, flashy brushwork, "shorthand notes," are not enough. It demands everything that oil requires, as to compositional excellence that will stand the test of time, while at the same time it wants to retain its own traditional characteristics—luminosity, fluidity, "accidental" passages, etc.

Both outdoor sketching and studio planning are desirable, the former for quick impressions and the retention of one's manual dexterity, and the latter for serious picture building.

Now for my own painting! Imagine me in the field, far from home—I face a picturesque scene—time is limited. I make a small pencil sketch, perhaps four by six inches. It may be rough and simple or very carefully detailed, depending on the force of reminder I may need; for the purpose of this sketch is to show me, later, the exact lineal and special plan of my composition. It tells where the expanse of my picture is to stop (on the left, the right, the top, and the bottom), what units are to be included, and where. Pencilled notes are made to tell the colors of the objects or the color I intend to use—and these colors are not necessarily the ones that the scene includes, for it should be easy to see, with all the details before me, that a red house, for instance, would agree better with its neighbors if it were white. In the sketch a house or a tree, or any familiar object, might be indicated with very few strokes, for from long practice I can paint such things from memory. A less familiar item, however, such as bronze statue, would have to be carefully depicted.

On the side or the back of the paper would be pencilled notes reminding me of the characteristics that first attracted me

to the scene—a peculiar glow in the sky, for example, or the unusual turquoise blue of a river passing over copper deposits—for I seldom select a subject unless it features, in my eyes, something of the unusual. Following the completion of the sketch, I might simply gaze at the scene for five minutes, preparing a mental inventory of the factors I consider necessary for a successful composition. Should there be other details demanding accurate delineation, such as possibly the elaborate Baroque carved stone scrollwork about a church door, I might take a camera snapshot with black-and-white-film.

Back at the studio, a day to a year later, with my pencilled notes, the possible snapshot, and with the remembered composition projected onto my mental screen, I then work out a color study in small size, perhaps 4 × 6 or up to 8 × 10 inches. This color study may be made directly over the original pencil sketch, on a photostat of same, or on an entirely new paper. When finished it will show exactly the colors, the values and the spacing of the parts that the final opus must include. The study is carefully made, for it is in this that the artist injects *himself*. Here one has to depend largely upon his imagination for results, for he works from reminders only. That is the beauty of the system, for it prevents the possibility of a photographic appearance in the painting—it must necessarily be largely inventive. By such methods the artist introduces only material that will help the picture, without being persuaded to include unnecessary detail, as he would were he painting directly from the scene.

This color study is done almost entirely with the brush. Accurate drawing is not essential. Chinese White and opaque

Street in Ciudad Rodrigo
Sketch reproduced actual size

colors are used if necessary. Often white is applied over color, and color over white—the performance repeated several times. In the end the study may appear quite messy from all the changing and adding and scrubbing and deleting and repainting, but as a composition it includes everything, except small detail that must later be included in the finished picture. Frequently, I spend more time upon the study than upon the final painting. The study represents the stage where all planning is done. It is the embryo whose genes, revealing their character in the final production, will establish the difference between a painting and a work of art.

From the study I make the finished painting—let us say a full sheet—22 × 30 inches. When ready for this, I am completely familiar with the whole composition; I know exactly what I want to do, and this knowledge enables me to work directly, without hesitation or uncertainty, so that the finished painting appears spontaneous and effortless (or so I like to think) even though, in reality, it has been carefully calculated to the last item. The only new additions, in the final work, are the necessary detail and the virtuosity of brushwork. A tree that was just a blob of color now has leaves—a blue stroke that indicated a door, on the study, may now be detailed sufficiently to show cracks in the boards. No opaque, white or gouache, is used on the final work.

This process, which in total may take from five hours to three days, enables me to reach for the perfection of composition seen in the best oils, while retaining the freshness, the fluidity and transparency typical of good watercolor—a result virtually impossible when pictures are painted completely in the field.

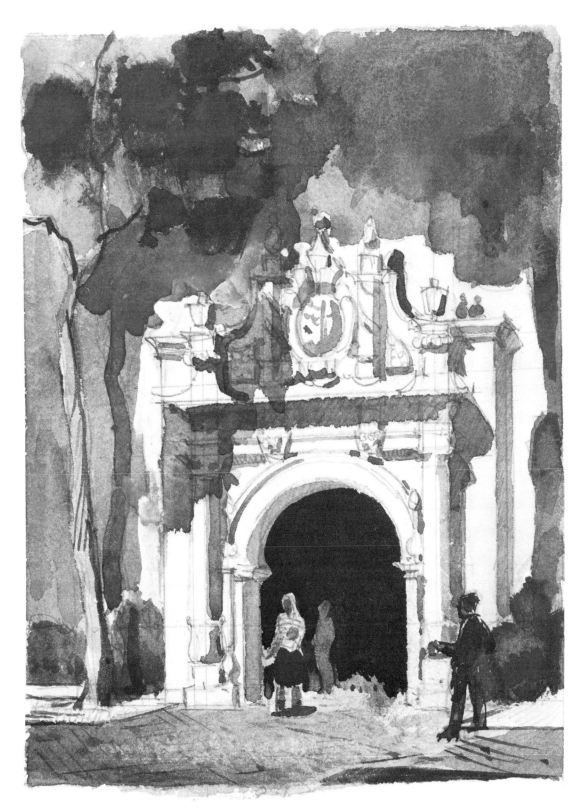

Whitewashed Portal
Sketch reproduced actual size

Working Over Watercolors

Watercolor is a jewel of many facets. The possibility of its being handled in so many different ways constitutes perhaps its greatest attraction.

The perusal of a book at hand, written many years ago on the methods of a dozen aquarellists reveals that no two approached their work similarly. Each seems to have approved what others of the group eschewed—and for that matter they may have been right, for good and bad are relative qualities, depending for their force on surrounding factors. But there is one point on which all twelve authorities agree. The verdict of the jury is unanimous. They say that watercolor should be applied and left alone—that working-over is dangerous. But by re-reading the sentence above which says good and bad are relative, I am prompted to differ with the judgement. Much of my own watercolor work is far from direct. I do change it about a good deal, for it is the only way I can achieve my ends.

Watercolor can stand a great deal of handling. In the United States at least this factor has been so forcefully registered that in national competitive exhibitions today few of the simple, direct, on-the-spot paintings could pass the juries. The prize-winning pictures, in large measure, are the carefully composed and carefully handled creations, with every detail right. And being right implies they may have been mopped out and painted over many times, either in the preliminary study or in the finished painting itself—for perfection in composition does not arrive fortuitously.

But regardless of the great labor applied to a watercolor, I agree with the twelve authorities that the painting must appear fresh. Freshness is the essence of the medium. How then is this freshness retained? The crux of the matter is the removal of paint already applied. Virtually any watercolor paint can be removed by methodical, skillful operation.

The implements needed for paint elimination and its various branches are:

1 A large, firm, flexible brush such as a flat, house-painter's varnish brush, about 1½ inches in width, with bristles perhaps 1½ inches long; choose one that assumes a sharp chisel-edge when moistened.
2 A round, flat-ended, stiff-bristled stencil brush ³/₈ to ¾ inch in diameter, with bristles about ⁵/₈ inch long.
3 A sponge.
4 A clean rag.
5 A razor blade, pocket knife, or similar blade instrument—sharp.

To remove dried watercolor from a space up to perhaps 2 square inches, we take the varnish brush, damp only, and swinging it continuously from left to right and back again,

edgewise, we apply it lightly to the indicated spot.

After a few oscillating strokes, it will be seen that the brush has cleanly removed the paint down to the white paper. We clean the brush frequently and continue the process over the paper until the whole spot is clean. With light, methodical brushing and tough paper, the surface will not be injured. We allow the spot to dry thoroughly. This is important. Then we repaint as desired, carefully, and the repair is invisible.

For stubborn color, in small areas, one may employ the stiff-bristled stencil brush—using plenty of water, cleaning the brush frequently and mopping up the pasty residue with a clean rag held in the other hand. This scrubbing process removes a certain amount of the paper itself, thus changing the character of the surface somewhat, not necessarily disadvantageous. We must scrub the spot clean, allow it to dry thoroughly, and then repaint it.

To remove paint from a large area, perhaps up to 2 feet, use the sponge or the clean rag, or both, and with clear water mop off the space under consideration, much as you wash a table top. Take it easy, be gentle, refrain from hurry, and be thorough. Over strenuous treatment will roughen the paper undesirably or leave abrasions that will reflect themselves in the later painting. When the paper is thoroughly dry it may be repainted.

Sometimes you may want to reduce to clean white a definite shape such as a 2-inch square, say, or the roof of a painted house. For this purpose it is advisable to apply masking tape around the part, leaving the desired shape exposed. Then, with the varnish brush, wet sponge or cloth, the section can be mopped clean. When dry the tape can be removed.

For very small spots, conceivably the size of a pea, simply dampen the spot with clean water, allow to stand a moment so the paint will loosen and then, holding the clean cotton cloth, with a tight, hard wad protruding from between the thumb and fingers, place the wad on the moist spot, press it down firmly, and with a quick sideways twist of the wrist, scoop the color spot right off the picture. If this is done properly, a clean, sharp, white spot will be left.

Razor blades and knives are often used for removing small areas of color. This may be done with the paint dry, in which case the removal leaves a definite scratch or scrape on the paper (objectionable to some), or it may be done with the area slightly moistened before the blade is applied. The latter process permits clean removal of color without damage to the paper surface.

The varnish brush may be used to lighten the value of a given color area without removing the color completely. Moisten the brush slightly, and then, using the flat *side* of the brush—not the edge—give a quick, heavily applied wipe over the spot. Continue until the value is a little lighter than de-

sired. Allow to dry thoroughly, and repaint with a light wash.

For a great deal of manipulation, use a good grade of paper, handmade, all rag, preferably linen, of substantial weight and with a tough surface. D'Arches, a French paper, is perfect for the purpose. Most of the better grade English papers will stand a good going over. Some watercolor papers are of intentionally soft composition, and any great amount of changing in painting will remove a 'skin' from the surface, making it almost impossible to repair the picture.

Soft papers have their uses and virtues, but they should not be used for vigorous handling. When soft papers are employed, the experimenting, mopping-out and painting-in should be applied to the preliminary study, and the finished picture on the soft paper should be painted after the final detailed result is already envisioned and can be achieved without a great amount of scrubbing.

No picture is finished as long as it can be improved. When a spot or line offends it must be taken out. Perhaps I am wrong in disagreeing with the twelve apostles of the brush-it-and-leave-it school, but I contend that no one can hit the mark with the first try. Just a good shot will not do. We must try for the bull's-eye.

A good watercolor must be *finished.*

Street in Alfama
22 x 27½ inches

The reproduction here, apparently painted with directness and assurance, was actually drawn very carefully. Color was then applied lightly, in correct hues, to most of the picture area. When dry the whole surface was mopped and scrubbed to blend the colors into a well-integrated base for the picture. The paper dried, the strong colors were brushed in simply and with verve, thus producing freshness of appearance without the 'rawness' sometimes encountered in over-simplified paintings.

Shadows and Magic Colors: How to Paint Them

Collectors of paintings who buy my watercolors all seem to be impressed by what they call "the unusual colors that you use and the striking shadow patterns that your paintings include." Presumably my interrogators feel that I have a secret palette of magic pigments.

Frankly, I had never thought of my paintings as being unusual in the two departments mentioned, but recent analyses seem to indicate that both commentaries stem from the same practice, and that practice is one that appears to be peculiar to the art of painting in watercolor, namely, the use of "washes."

At work, the watercolorist is able to cover great areas of paper with paint in a short time by very wet "washes"; where as the painter in oils, the worker with pastel, pencil, ink, or virtually all other workers in the visual arts must cover the areas of their compositions with individual, relatively small paint applications of pigment, say, one brush-stroke at a time. This difference in color application gives the aquarellist a great advantage over the other art workers. Also it enables him to achieve passages and color combinations that are truly unique.

In my own paintings, the colors used are no different from those used by artists generally, but I can see that my frequent use of gray "shadow colors", washed over regular colors, may explain the erroneous idea "different" colors have been used.

I use a great amount of gray paint, applied as washes.

Assuming that I am painting a composition in strong light—which, of course implies a strong shadow pattern—I will paint the whole scene in local color, forgetting the shadows, and then, when the color on the paper is thoroughly dry, I shall mix up an amount of "shadow-color" and paint the whole shadow pattern with it. This naturally pulls the whole composition together. This system saves the trouble of mixing up red-shadow paint, blue-shadow paint, and the like.

Naturally, the simple practice described above leaves the work looking over-simplified, lacking in sparkle, but this can be readily corrected by adding, here and there, a softening of

some of the edges with a bit of water, adding a few dark accents, and so on. Other washes of shadow-color may be applied, if desired, to finish up the painting.

You may say, "When you brush one color on top of another, the one underneath loosens up, mixes with the new color which makes a messy and unsightly passage."

This is a common complaint, but the trouble can be averted; one color *can* be painted over another if we remember: (1) The first color must be thoroughly dry. (2) The new color must be applied quickly, without being put on in the form of a loose wash, without applying one brush stroke over another. With a little practice you can paint as many washes over others as you desire, but be sure to obey rule number one.

Artists' Colors—How Long Will They Last?

When an artist takes the making of his pictures seriously enough to expect others to buy them, common decency indicates that among the least of his responsibilities is to use, in his picture making, materials that will stand the test of time.

Few will quarrel with that statement, yet is astonishing though true that many artists, through ignorance, are negligent in this respect. In the matter of colors, for instance, many know virtually nothing about the lasting qualities of the pigments they employ—this despite the fact that most paint manufacturers are quite ready to give all needed information. Many artists naively assume that all colors made by reputable houses or colors that are "expensive" are consequently permanent. Nothing could be further from the truth. Few of the leading manufacturers claim that all their colors are fast. It is not necessary that all colors be permanent. Some of our most exquisite and most easily manipulated hues are of a fugitive nature. For certain purposes, as in paintings for commercial reproduction, colors of temporary durability are quite acceptable.

Permanency of colors has relatively little to do with their manufacturing source. There is no great secret to the making of standard paints, and most manufacturers follow the same principles. Artists' colors for the most part are nothing more than raw dry color well mixed with a binder, such as gum arabic or other soluble gum for watercolor, a casein glue composition for casein paints, and an oil mixture for oil colors. Naturally there are different degrees of excellence in the material used and the care employed in the grinding or mixing, but basically the lasting quality of the paints you use depends upon the kind of raw

pigment in the mixture. Commercial paint manufacturers do not make the raw powdered pigments. They buy them, and they all buy from similar or comparable sources. So to know about the permanency of paint colors we must learn something about the basic powdered pigments or the dyes that are sometimes used. We shall come to that in a paragraph or two.

Most paint makers mark their colors about as follows: ABSOLUTELY PERMANENT—REASONABLY PERMANENT— or NON-PERMANENT. Some houses also issue printed material telling of the source and quality of their pigments. Often you'll hear the comment that the word "Permanent" cannot be qualified and that anything "Permanent" is necessarily "Absolutely Permanent." This seemingly redundant method of marking needs explanation. "Reasonably Permanent" means permanent under ideal conditions. "Absolutely Permanent" means permanent under all conditions short, perhaps, of subjection to fire. Example: Certain colors that would be permanent if protected from sunlight or if kept in chemically pure surroundings could be faded in bright sun or altered by the sulphur fumes often encountered in the atmosphere of industrial centers. Pure ultramarine, derived from lapis lazuli, is one of the most durable of colors—it is "absolutely permanent". Yet a drop of lemon juice will destroy it immediately. So it will be seen we have to qualify our terms.

Most earth colors (pulverized soil or clay) are absolutely permanent. Even in strong sunlight they seem never to change. Earth colors include: The ochres, siennas, umbers, mars yellows to violet, terre verte, etc. Other absolutely permanent popular colors are: The cobalts, blue, green and violet—the cadmiums, reds, oranges and yellows—the chromium oxides, viridian, etc.—the iron oxides, Indian red, Venetian red, etc.—to mention some of the best known.

It might be considered advisable to list here all standard colors, noting their degrees of permanency and their compatability (or lack of it) with other colors, but development in the color industry has been so rapid in recent years (note following two paragraphs) it would be difficult to offer factual statements that would apply to given colors made by different factories. The maker of your favorite brand of colors will almost certainly give you information about his product, on application.

On the classified data on pigments, publicly distributed, much of it was published some years ago, and in large measure they refer to the varied sources which have been standard for a long time, in some cases for centuries. And these sources have been many indeed, from plain asphalt (bitumen) to the urine of cattle (pure Indian yellow). Ranging through the three classifications of matter, animal, vegetable, and mineral, they embrace such diversified material as ground insects (cochineal-carmine), burned bones (ivory black), extract of roots (rose madder), coal tar material, and any number of metallic deriva-

tives. Because of these many and varied bases, it has been found that certain colors cannot be mixed satisfactorily. Chemical action takes place through combination, and gradually affects the color. For instance, pigments with a copper base, such as Malachite green, may tend to blacken if mixed with the cadmium sulphides, such as the cadmium yellows and oranges. We are advised to keep separate certain chromates (chrome yellow, etc.) and organic colors (made from vegetable or animal sources). Color manufacturers will supply leaflets giving detailed information on the many forbidden combinations.

During recent years, some firms have replaced some of the old formulas with synthetic productions, or they have added the synthetic product to the old line. Emerald green, for instance, in its pure state is aceto arsenite of copper, and as such should not be combined with, say, cadmium yellow. As synthesized, by some makers, emerald green is simply a mixture of two other standard colors, a blue and a yellow, so if the synthetic color is used, the taboo is removed. Many of the new colors are aniline or coal tar products so, being of a more homogenous nature they may be mixed with each other without danger. Some of the synthetic colors are claimed to be absolutely permanent by their manufacturers, and if they are permanent they are acceptable for use by fine art painters, but it is advised that we do not accept too readily aniline or coal tar colors in their entirety, for many certainly are not permanent or otherwise desirable.

In my own palette, I use only colors that are absolutely permanent, with one exception. That exception is alizarin crimson—and I use it very infrequently and very sparingly. There is no absolutely permanent crimson or rose red color. In most of my work calling for crimson, I use cadmium red with cobalt violet added. This makes a beautiful hue but of course is not the same as crimson, nor does it have the brilliance of crimson or of carmine, but as most colors have to be muted anyway in a fine art painting, one can quickly adjust himself to the lack and will experience no difficulty in expressing himself adequately.

May We Copy the Work of Others?

Frequently we are asked about the advisability of copying the work of others as an aid in learning to paint.

We all know, of course, that at one time copying was common practice. We also know the idea is now rather generally frowned upon, especially by those who consider themselves to be in the educational vanguard. In fact, one of the tenets of art teaching today is that the teacher should not impose his viewpoint or his style but should, rather, help to

bring out the pupil's own personality and talents.

We also know nothing intrigues the professional art-discusser like a theory and that facts are invisible to some when their theories are threatened. Well, like many pedagogic theories this one about the inviolability of the student's personal inclination sounds a whole lot better than it works—for two reasons. In the first place, a great soul cannot help encouraging imitation in those who admire him, and secondly, there is no legitimate reason why we should not imitate our betters. Of such stuff is progress made. For whether we like to admit it or not, there is no such thing as completely creative thought or production. It has been stated that the human mind at birth is like an empty vessel and only that which first goes into it can later come out. The ingoing and the outcoming ideas may not closely resemble each other, going in blue and yellow and coming out as green—but all new thoughts and new accomplishments stem in some way from earlier happenings. The more we know of the past the better we are able to contribute to the future. Surely a young child removed from all human contact would grow up an ignoramus. Furthermore, observation leads one to believe that artistic skills developed by those deprived of instruction are not really original but have been garnered, perhaps unconsciously, from others.

To talk, then, of bringing out the personality or individuality of a child, without allowing others to influence him, seems rather unreasonably, for personality is nothing more than the sum of a person's contacts and his selections.

In the old days, art was taught by the master to the pupil through enforced imitation. The apprentices became facsimile copies of their leader, and a new school was born. Later, these apprentices, absorbing ideas from widely varying sources, radiated completely new thought combinations and became creators of schools of their own. We have already seen that if enough colors are dropped into the magic pot, rainbows or any other patterns may be brought out. In fact, this is the only way that improvement can come about—by mutation. Nothing since Genesis has ever arrived by independent creation. There is nothing new under the sun. Let us not deceive ourselves; there are only new combinations and new mutations.

Now, regardless of the supposed value of our modern thought and the imagined disadvantage of direct copying, it is doubtful if anyone will deny that by actual development of real artists, the now discredited apprentice system produced more and better results than our present scholastic system. It's a long time since we had a Leonardo, Michelangelo, and a Raphael producing at one time. Let the opinionated debator sink with his theories; an openminded observer abides by the facts.

So, I say, let one copy if he likes. He will thus learn in a few minutes reasons for procedure that might require months to

ascertain by his own fumbling and guessing. But when one has appropriated all an instructor has to offer, let him seek elsewhere for inspiration. To be a slave to any one idol can become dangerous. An artist should absorb the best of everything he sees, and when his vessel is filled with different viewpoints he can issue his own messages in color which will be as nearly original as any later "creations" the world is likely to see.

Painting From Photographs

A question frequently asked is whether it is ethical to paint watercolors from photographs.

May I suggest that the important point in any project is to achieve the goal—to get the job done—and anything that will expedite that end, without working injustice to others or without reducing the value of the final composition, is not only acceptable, but virtually mandatory. The use of photos is usually adopted to save time. No one has a right to waste time or energy voluntarily.

A photo represents nothing more than a transfer to the studio of an actual scene, and if an artist expresses the same care in composing his painting, from the photo, that he would have used out there in the field, the finished results should be equally fine and equally acceptable.

The general assumption seems to be that if photographs are employed, the finished watercolor will be a "copy of nature", on the theory the artist, left alone with a corruptive photo, hasn't strength or sense enough to use the print solely as an inspiration, to omit from his painting those photographic details of no importance, or to insert the needed features the photo lacks.

That assumption and all the talk of "photographic" paintings has been considerably over-embroidered by those who employ rules to take the place of reason. Such talk is often favored by professional non-artist art-discussers, those fresh from exposure to the voice of art authority, or those artists who could no more paint a good, detailed, realistic picture than they could build an iceberg. Many paintings labeled "photographic" simply because the details are accurately and carefully handled, require in their construction many times the inventiveness and artistic ability demonstrated in certain other so-called "progressive" pictures. There is no virtue, per se, in painting realistically, and there is no particular virtue either in painting unrealistically. The amount of detail in the picture, accurate or inaccurate, has nothing to do with its success as a work of art. The artist who achieves results is the one who will be remembered. Results, not theories, are the deciding factors.

So if one can improve his work and save time by working

from photos, he should by all means work from photos. Only one admonition is to be remembered: the artist must not copy the photo any more than he would copy its original. Both are to be used only as bases for operations, not as the final objectives.

The Beauty of Detail

Hail Mary, Full of Grace!
22 x 30 inches 1973

In view of the kind of contemporary art exhibitions which the museums now permit us to view, one might question the fact that, in the opinion of many, the prime purpose of picture painting is to increase the world's store of beauty. At least, in the minds of the majority, beauty should not be by-passed.

There are many varieties of beauty that can aid to the charms of a painting. They include the beauty of:

1 The subject matter itself.
2 The painting's first, overall impression.
3 Color combinations.
4 Expert draftsmanship.
5 The artist's style of painting.
6 The picture's mood.
7 Detail.

It would be too much to ask that every painting include all of the above-mentioned desiderata. Of course there are many good reasons for painting pictures besides the worship of beauty. These justificatons include: The conveying of an inspiring thought or emotion—the telling of a story, as an illustration—propaganda.

Today many paintings fail to find themselves included within the possibilities just recounted nor the seven varieties of beauty. I wonder why!

The various divisions listed above are well known to most art enthusiasts, but I should like to expatiate upon the beauty of detail, as this possibility is frequently overlooked.

Certain artists like to register a composition in dramatic style, with bold brush strokes that preclude the possibility of showing much detail. There can be no objection to such a technique, but there are other courses that can sometimes be desirable and legitimate—courses that provide similar dash and which, in addition, reward the close-up viewer with a rendition of more carefully painted detail. There are some scenes whose chief attraction is the beauty of *detail*.

As a example: I have before me a painting made of a series of antiquated dwellings in the town of La Alberca, in Spain. I shall venture the guess the age of every building in the community exceeds two hundred years. Each dwelling could serve as the subject of an outstanding work of art, largely because of its varied, interesting, and unusual detail. The foundations of most are of blocks of stone. To that material is added a great deal of mortared work divided into panels by weathered wooden timbers—verticals, horizontals and diagonals. Patches of plaster are broken away, exposing the rubble, brick or stone underneath. Add to these the painted stucco surfaces, worn and grayed by time to a batik-like patina, the picturesque grain on the timbers, the out-of-plumb lines and planes of the basic structure and an old-fashioned design of the buildings as a whole, and we have a combination of unusual detail so artistic,

decorative and pleasing it would be sheer waste to overlook. True, a good painting could be made from such a subject in an impressionistic or broadly brushed manner, but this offers no argument against painting another picture of the same subject in which the detail itself is the principal—though not necessarily the only—desirable factor.

Until the coming of the impressionists understandable detail was a very important ingredient in most paintings. Perhaps we have gone so far in our worship of bravura in painting that we have overlooked the charm detail can provide.

Now I do not suggest all paintings be treated in a trompe l'oeil style. All things are relative. Detail itself can be painted in a relatively broad way which at least suggests the details of the detail (such as the cracks in weathered timbers) without painting the scene microscopically.

Detail is the bugaboo of many artists. Let's exorcize it.

Seventeenth Century Relics

The Suppression of Ornament

One phase of the art situation I have never heard mentioned is the suppression of ornament. What is ornament? It is an embellishment of some kind applied to an article already designed for a specific purpose. Ornament does not stand by itself.

Since the human race began man has had a natural desire to decorate his possessions—tools, clothes, homes, palaces, books and what not. And that decoration has ranged all the way from scratched lines on shells to the most exquisite productions in carved stone, mural paintings and the like. Most of it has been inspired by natural forms: the human figure, animals, flowers, leaves and other vegetation, waves, clouds and so on though some has been purely non-objective or geometrical, such as guilloches, cartouches, the Greek frets, and so forth. Saracenic artists were forbidden by their religion to employ in their work likenesses of any living things, animal or vegetable; but with scrolls, inscriptions, geometric devices and colors they managed to devise a fascinating style of decoration.

Ornamentation was carried to its ridiculous extreme in the Spanish Churrigueresque style, in which practically every foot of architectural space was covered with embellishment.

Concurrently, with the coming of abstract impressionism and the new architecture, ornament became taboo—in architecture, furniture, printed forms and everything else except, surprisingly, in just a few departments—those devoted to pleasing women, such as jewelry, draperies, dress materials, etc.

Not so many years ago printed designs, as exemplified by book covers and title pages, head and tail pieces, letterheads, trade marks, diplomas and the like called for a good amount of fanciful elaboration. Today, straight typography, and stark, ruled lines, are about all the authorities will accept. Trade marks, in most cases, have been reduced to severe monograms or other letter combinations. Hard, sans-serif letters have replaced the more graceful Roman examples. Few designers today would dare to draw letters of their own imagining, so they have them set up by the commercial typographer. In architecture ornamentation is positively excluded, unless we can bring those shapeless surface patterns in Portland cement within the meaning of the word. Many books have been written analyzing the styles of ornament of different periods. One would have difficulty finding modern material for such a publication.

To be an architect, in the past, one had to be an artist also. Today, architecture is more engineering than art. Without ornament architects have developed an amazing new style, but

one must ask if it would not be even more enchanting if ornament were included in certain limited areas. Absence of ornament brings most criticism of modern architecture.

Ornament, of one kind or another, has always brought pleasure to its beholders—to the professional and non-professionals alike. One can understand a desire for restraint and for an original style of adornment, but to say we must have no ornament whatever—as the authorities do say, in effect—is downright senseless. Anyone who deliberately and arbitrarily discards any whole division of helpful factors is not very bright.

Of the best-known styles of ornamentation, the Rococo and the Baroque have been considered the most vulgar, but when you encounter a good example of either today, after viewing miles of unadorned, box-like buildings, it provides a pleasing surprise. If you now seek ornament you must turn to antiques or period pieces.

Already a reaction against decorative sterility has set in. Art Nouveau, which flourished at the end of the nineteenth century and which was founded upon the flowing or curved line to the almost complete exclusion of the straight line, has again become popular. In the department of illustration and printed ornamentation, Aubrey Beardsley was its chief exponent, at least in English-speaking countries. Because of its allergy to the straight line, probably, Art Nouveau was condemned as an effeminite style and it flourished only briefly. Most Americans never heard of Art Nouveau until reading of its recent resurgence.

That the reaction against present day decorative barrenness should take us to that other extreme, Art Nouveau, demonstrates the strength of the urge to reform.

From Painter to Artist

"Nothing quite as pretty as Mary in the evening kissed by the shades of night, and with starlight on her hair."

Listening today to Glen Campbell sing one of his love songs, I was impressed by the phraseology used by the composer. The above is an example.

That will be the subject of our art lesson today, for it suggests a fact that is very important when one designs a composition, whether of words, musical notes, paint and brush or whatever. It demonstrates the difference between artistry and simple technical competence—between factual recording and imaginative creation.

The gist of the lines quoted above could be conveyed by saying, simply: "Mary is beautiful in the evening." But that would be commonplace—prosaic—even though it could be called good reporting.

In the field of painting, we see two classes of workers—

those who know how to reproduce on paper or canvas exactly what they see before them, while the other class we find those who mix imagination with their dexterity and produce valuable works of art. As art practitioners we must first master stage one before going on to stage two. We advance from "painter" to "artist." But the sad fact is that many never reach that final status or even know that a dividing line exists. Many talk in cliches and paint the same way—without imagination. Cliches are the foe of artistry—whatever the mode of expression.

The author of our opening quotation (whose name I do not know) has taken a simple statement of fact and, using imagination and feeling, has given us a lovely, lilting air.

Lessons learned in one field of activity can be applied to other activities of similar nature, so let us, as workers in the visual arts take to heart the lesson taught us by the poet.

Understanding the Art Viewer

Over the years I have organized, juried, hung, and supervised many more art exhibitions than have been my due; and as such work compels you to answer all incoming comments, critical or complimentary, I am satisfied I now sense the attitudes of gallery-goers as well as any artist can.

Of the non-professional visitors there are two general classes—those who have received and accepted the current official art-thought indoctrination and those who "know nothing about art but who know what they like." The first mentioned knows all the answers, so there is no point in our presuming to add to their knowledge. I frankly confess that about art I *know* very little, though I have certain very definite opinions—so let me address those of the second category who approach an art gallery with a fresh mind unencumbered by externally imposed prejudices, at least. Never for a moment would I urge the complete discard of their ingenuous if somewhat unappreciative attitude. To encounter such is refreshing and if, instead of deriding it, we agree to inform its owners as to what ingredients are desirable in a successful picture and why, we may increase their enjoyment and at the same time encourage admiration for its creator.

Let us talk today about just one pictorial factor, that of subject matter or the theme of the painting and treat other factors later. The average layman judges painting almost entirely on their subjects, with surprisingly little regard for the qualities that make certain works of art great, namely; dramatic quality—brilliance of handling—and originality of conception, composition, color and style. Said layman likes his art neat. He dislikes gloom, decrepitude, disarray, moodiness and unclean-

liness, which of course is commendable, when these conditions are present, in reality. But he doesn't see the painting itself so much as the scene it comprises.

Now there is nothing to prevent the painting of great art around an "attractive" theme, but we are justified in giving such a picture a second review before accepting it finally, for in fact many artists, familiar with the human traits just described, do take advantage of their admirers by painting only "sweet" scenes to hide their own artistic inadequacy. Contrariwise, many capable artists, also aware of human tendencies but too ethical to ride on the coat-tails of the non-professional's sentimentality, carefully avoid "cute" themes.

If subject matter alone is to be the criterion, photographs are better than paintings, and there is no need for the artist. A primary purpose of painting is to create beauty—an arrangement of forms and colors which, *of itself,* will provide visual enjoyment. This explains why certain *abstract* designs are often delightful. The theme itself need not be held important provided the composition itself has appeal. The artist, from long practice, learns to see the *painting,* not the scene painted, and it would help the lay observer to develop a similar ability. A dirty alley with decrepit houses may be smelly and suggestive of other unpleasant conditions—but it *might be beautiful* if vision alone could perceive the pleasantly arranged masses and colors, while our other senses were suspended and the suggestions of squalor thus tuned out. A capable artist has this power of concentration and exclusion, which is fortunate, for it accounts for the world's store of painting masterpieces of humdrum or even vulgar subjects.

We must remember also that all attractiveness is not the same order. There is prettiness and there is beauty. The former is lighter, if no less desirable, but beauty approaches more closely to grandeur. We might divide beauty into "feminine" and "masculine" classifications. The former suggests grace, refinement, and perhaps fragility; it is more civilized or polished. Also it is more easily understood and appreciated than the masculine, by both sexes. The latter refers more to strength and solidity. A massive architectural structure possesses masculine beauty, while its colorful gardens might be termed feminine. As indicated, we all love the feminine type instinctively, but it may take greater perception to appreciate the masculine—the primitive, and sometimes even the brutal.

Many of the great works of art, literature, and music have been masculine and thus required more time for acceptance. Wagner is masculine—Chopin feminine. Much masculine beauty is included in contemporary art exhibitions of the better grade.

So I recommend when viewing paintings (the same rules of course apply to sculpture) we beware the sentimental appeal of

subject matter, separate it in our minds from artistry, and confine our judgement to the composition within the frame rather than the scene it represents.

How to Judge Paintings

Paintings are customarily made and purchased for one of two reasons: for their value as additions to collections or for their appearance, meaning their beauty or their informative or inspirational value.

We must bear in mind that professional collectors—individuals or museums—are not necessarily interested in a painting's appearance. To them the value depends on the fame of the artist, the scarcity of that artist's work and whether that artist's work is favored by the currently reigning Establishment. The appearance, that is its beauty, craftsmanship, or joy-giving qualities, has little to do with a professional collector's desire to own a certain painting.

To my way of thinking the only value of a painting is its *appearance,* and that appearance can be good or bad regardless of who paints or signs it. From an artistic point of view a given painting by a great artist may be miserable and aesthetically worthless, while a particular painting by an unknown artist may be thrilling. I for one cannot be enthused about a painting simply because of its collector's value.

A collector of clocks doesn't buy them to tell the time; a collector of guns doesn't plan to start an insurrection, and a collector of art doesn't acquire pictures for the same reason that inspired their creation. The clock maker, the gunsmith and the conscientious artist do not make their product in the expectation that it will be housed in museums. Nor does the average lover of art view pictures for any other reason than the joy or inspiration they give him.

In view of the emphasis above on *appearance,* you might erroneously decide that I consider a replica of another painting to be as valuable as the original, in as much as the two would be identical in appearance. I know the pecuniary value of the copy is far below that of the one copied, but I do feel the inspirational value of a perfect copy should provide as much pleasure to the appearance-lover as would the original.

Naturally I would like to own a thousand dollar scribble by an Establishment favorite, but only so I could sell it, I wouldn't think of including it with my assortment of eye-pleasing treasures.

The real value of anything should be judged against the background of its real reason for being—not by the high prices paid by those who seek only uniqueness. The collector's value and the real aesthetic value of a painting can vary widely.

Sherman Monument
22 x 30 inches

We Think We Know What We Like

Nothing surprises us more than to find something which is pleasing to us is repugnant to others.

Of a jury of eminent artists recently judging entries for a national art exhibition, one stated: "That picture is the finest canvas C---------- has ever painted." Said another: "It stinks." A heated discussion ensued. Later I questioned both artists closely on the basis for their thoughts and was forced back to the realization, as all of us frequently are, that much which passes for fact is nothing more than opinion. All artists think they can tell good pictures from bad. But can they? The Supreme Court says "the law means what we say it means." Virtue in art is what the authority of the moment decides. The good of today is the bad of tomorrow—and vice versa.

Frequently it is said "there is no accounting for taste."

That is not really true. Taste can be understood, once it is defined. First we must realize that taste is a natural quality only in a very limited degree. It is almost entirely an acquired ability. It consists in approving what current leaders tell us is good. We like or dislike things not because they are inherently likeable or otherwise, but because we have been told to like or dislike them, or because somehow we have been persuaded personally to develop an attitude toward them. Few will accept this statement without protest, which refusal itself may be corroboration of a sort of the truths we are here trying to expound. Followers of a common leader have similar likes and dislikes, and those likes and dislikes will differ from the views held by the followers of a leader with opposing thoughts.

A publicity director said to me, "Give me enough money and I can make the people think what I want them to think—or what *you* want them to think, if you will pay the bill." And he could!—not every individual, of course, but certainly the great majority whose thoughts constitute "public opinion."

There is no such thing as absolute good or bad. Thousands of examples can be quoted to prove there is little agreement on what these terms encompass. For example, many foods considered inedible by Americans are relished as delicacies by others. The styles of architecture, of dress, etc., and the patterns of behavior of yesterday are not acceptable today, and the patterns of today will be rejected tomorrow. Orientals have little feeling for occidental music, and a similar stand is taken by occidentals on oriental music, but either can *learn* to like the other's compositions. The tastes of youth differ from those of age. Most individuals adopt the political and religious beliefs of their parents, thus demonstrating that our "thoughts" depend largely upon outside dictation. The sins of one country are the virtures of another. Most "sin," impropriety, and poor taste could be abolished in a flash simply by changing the rules. Whether a thing is desirable or undesirable depends upon the criterion used, and it seems human beings, especially artists, follow criteria that are quite individualistic.

Most of us feel, understandably, our own ideals, so patently sensible and admirable, to us, should appear equally praiseworthy to others, but this attitude in reality is accountable for a great deal of misunderstanding in the world. In practice we are prone to judge others' actions by our own standards. Such practice is somewhat unfair because the success or failure of an action depends upon whether it accomplishes the end desired by the actor and not the end conceived by the judge. Now I do not contend that a court should adopt the burglar's ideals in judging the burglar, for burglary is an unpraiseworthy undertaking, except to other burglars, but I submit that among praiseworthy efforts, such as picture making, thousands of different viewpoints can be registered.

Whether or not any of the results are good or bad depends largely on who is judging them. Note Shakespeare's quip, "A jest's prosperity lies in the ear of him that hears it, never in the tongue of him that makes it."

To be a fair judge, you must be able to subordinate your own customary opinions and be willing at least to consider the viewpoint of the one judged. Few of us are able to do this. Hence the unlikelihood of our ever understanding anyone on anything unless some superior force has already imposed mutuality of viewpoint or standard upon us or until such agreement in attitude later arrives.

Agreed, then, that anything, or nearly anything, is good or bad, artistic or inartistic, palatable or unpalatable, melodious or harsh, according to what we have been taught to believe. The question arises, "Why strive for the attainment of beauty? Why not take what comes to hand and simply change our viewpoints or wait until the general criterion resembles our own?" A good question. Many a philosopher has eased his own way by adopting the suggested principle, at least as far as unphilosophic society permits him. But most of us haven't the power. Individually we "know" only too well our opinions are unassailable. We can't don or discard them like clothes. We don't want to change them. We must await the slow process of allowing abstract thinkers to come along and change our opinions and habits for us.

But whether we accept these statements or not, we can save time and friction by adopting attitudes suggested by them. May I offer a few examples? Let us not excite ourselves when another person's opinions differ from our own. The only reason we ever agree on anything, let me repeat, is because some influence common to all of us concerned has given us similar standards or points of view. Then again, let us realize that all complaint and argument, or even discussion, is futile only unless the cause of the irritation rather than the result is considered, and then only if the words can fall on the ears of someone in a position to improve the situation. Let us go slow in attempting to force our convictions on others. Let us refrain from insisting others hear *our* opinion on every subject that arises. Let us refrain from carping on details, and reserve our recommendations for important, basic matters. Let us lose no time in recriminations. The present and the future are all that matter. We can do nothing about the past.

The past has gone—and even the ruler of the universe can't change that.

What Makes A Painting Outstanding

As a child I lived in one of those brick houses in the oldest section of Philadelphia where no new dwelling had been erected in a century. We needed new quarters so my mother sent me, a nine year old, to scout vacancies and inquire about rents. In those days, or in our set, real estate agents were unknown. You tramped about seeking "For Rent" signs. My mom failed to be thrilled by my daily reports until I described "a brand new, shiny brick house at a low rental" and led her to the "find." Still clear on my mental screen is her look of frustration as she explained that the "new" bricks and mortar were simply red and white paint and that the house itself was a wreck. It was a sad lesson.

Often I am asked for advice by non-artists on the possible purchase of paintings or I am called upon to be enthused about those already bought and, knowing the taste of the inquirer, I am reminded of my "new" brick house. These friends are impressed by "show"—they don't see through to the facts. They are attracted to a "pleasing" subject or color scheme or a "tricky" style of brushwork, while overlooking the importance of *structure,* that is, the real artistic quality of conception and execution.

What then should you look for when evaluating a work of art? Frankly it isn't possible with words alone to convey such knowledge to another, but if you will attend museums or study good printed reproductions of paintings thus familiarizing yourself with the works of the masters *that have stood the test of time* and if you will seek in them the three ingredients listed below, the beauty and soul of the paintings and the skill required to produce them will manifest themselves more readily with each inspection. From then on when viewing contemporary work you will be able more easily to detect the presence or absence of those qualities that make a picture outstanding.

CONCEPTION: Every picture tells a story. That is, the artist uses his skill to convey a thought. If he doesn't communicate *something* to the observer his effort is wasted. Some pictures actually describe an episode in paint as a writer would describe it in words ("Washington Crossing the Delaware" for instance). Other simply impart an impression; inspiring, depressing, or otherwise, in the same way that a poet reminds us of "Spring", let us say, without actually describing it. *Conception* is the spiritual quality of the painting. Strive to analyze it. Is it worthy, noble, thrilling, uplifting, meretricious? Or what? Render your decision on that conception.

COMPOSITION: Composition refers to the arrangement of the visual ingredients of a picture—its pattern, in other words.

It is unrelated to subject matter or spiritual quality. Composition has to do with spacing of masses; with colors, their depths and combination; with direction of lines and shapes; with contrasts of lights and darks, and the like. It provides *balance* to a picture, or *repose,* so everything keeps its allotted place, be it important or secondary. In a good composition the spectator's eye enters the picture easily, travels about through beguiling passages, reaches the focal point and then moves elsewhere until all areas of the picture have been seen. The eye never moves *out of the picture* but always returns to the center of interest, which is predominant but not obtrusive. These conditions are not accidental but are the result of the artist's skill.

To the uninitiated the presence of good composition is not even apparent, but even the beginner can sense that three is something wrong in a poorly designed picture.

Composition, and this business of controlling the spectator's visual travels, might take volumes for full explanation, but once the gallerygoer senses their importance he can soon learn to recognize them.

MANNER OF STATEMENT: An artist expresses himself with brush and color, as most of us express ourselves with words. Among conversationalists we find exhibitionists, fakers, those given to overstatement or understatement, sound thinkers, those who express themselves clearly or poorly, and the like. There are as many kinds of artists as speakers, and their personal qualities show in their pictures. With experience, you learn to pick the solid ones in art as easily as in conversation.

The Distinction Of Being A Representational Painter

I am classified as a representational artist. That means that the things I paint are recognizable to the observer. Repeatedly I am urged to "go Modern"—to mount the band-wagon of the "avant garde." I am reminded that if I covet the plaudits of the powers that be, those who give the nod, who confer the accolade, I must give up representationalism. Recently one of the country's leading "traditional" watercolor painters confided to me that he is about to make the switch.

An official of the Metropolitan Museum of Art offered me privately this observation: "Representational painters are no longer being invited to important national shows." A former president of one of the largest Western organizations writes that his association is going completely "abstract." He continues: "For our shows I now submit 'abstractions', along with other

conservatives you know, although we have no genuine enthusiasm for such work." These are only a few of the many examples that might be quoted to prove what every active artist knows and to demonstrate that the direction of American art thought has been taken over by "anti-representational" authorities.

While the Modernists themselves are divided into any number of splinter groups, they all seem to agree on one point—they don't like representational art, or naturalistic or figurative art as it is sometimes called; and realism is actually the factor that separates the two great groups, traditional and Modern.

From sitting on many, many art juries and inter-society committees throughout the years, I have had an opportunity to observe how the juror's mind works. In the case of the average "progressive" judge for instance, I notice in making his decisions he picks and chooses among the "avant garde" pictures—quite honestly, of course—but does he pick and choose among the representational pictures? He does not. He excludes them—ALL!

Representationalism is the only ISM that has persisted through the ages, all others having petered out after about ten or fifteen years. It is the only style of picture making that has been accepted by the people generally; and no art can achieve lasting success without popular approval and support. Painting realistically will continue long after the present *isms* are forgotten. It is the only style that *can* continue, for the others, based on restrictive concepts, must eventually suffocate in their self-constructed dead ends.

I have no objection to "progressive" art as such. I believe in tolerance for the thoughts of others, but I do object to the boycott against representational art by those who call themselves "creative" and the non-artist "authorities" who hold control of contemporary art thought.

I realize that in our field the amount of realistically painted trash is as great as that of the non-realistically painted trash, and I hold no brief for the producers of either. But we must reserve great admiration for the masters, the representational artists whose work will stand the test of time, the courageous ones who refuse to be stampeded by the herd, who go along in their quiet, assured way, striving through experimentation for better and real, if gradual, improvement.

They are the impressive art figures of today.

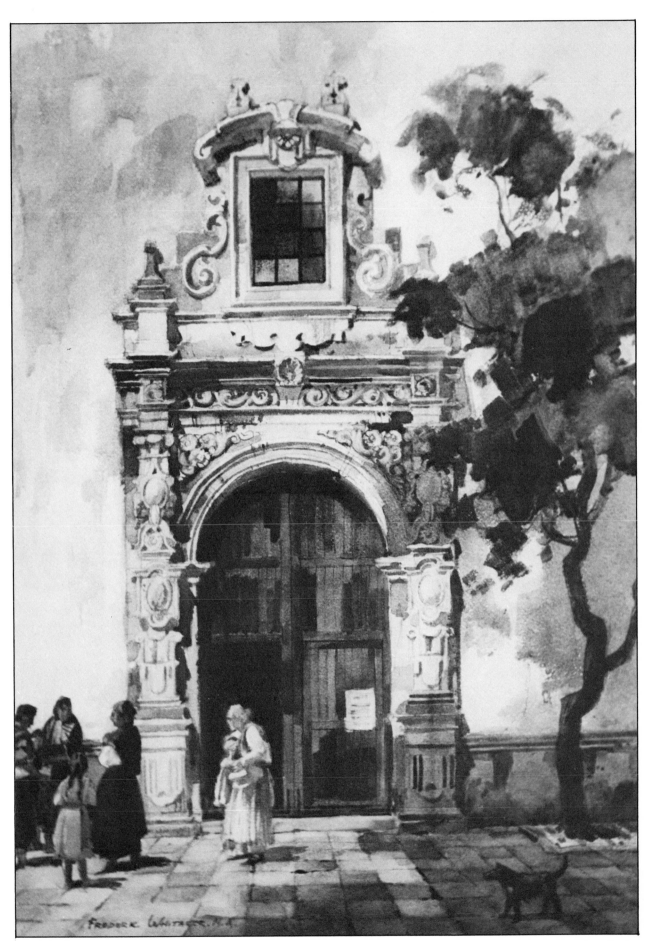

The Pink Portal
22 x 30 inches

The "ISM" Painters

A correspondent asks if I "approve of 'ISM' painting." Better ask me if I am in favor of maple trees, or cherry or cedar. Surrealism, Primitivism, and all the other ISM's are simply different branches of the whole art growth. Whether I choose maple, or Abstractionism, at any given moment depends on the purpose I then have in mind.

Since agreement on meanings is the first step in any discussion, let us arrive at a definition of "ISM." To me it seems to be an art movement or "sport" as the botanists would call it, growing out of while differing in nature from the parent body. The ISM, gets its impetus from emphasis on a single one of the many possible characteristics of art expression, while the others are unstressed. For examples, Cubism insists upon geometric technique; Impressionism specializes in light refraction and so on. In each ISM some of the picture components customarily used, such as atmosphere, perspective, chiaroscuro, are discarded.

"Modernism" in America may be reckoned from the Armory Show of 1913, when the French Cubistic, Post-Impressionistic, and other new movements caused such a furor. ISM's have existed before, but they had striven in a general way, if by other means, to produce what had until then been accepted as beauty. After 1913 the "Moderns" were to insist the old conceptions be thrown overboard and an entirely new brand of beauty substituted. Many opponents were so uncharitable as to complain that the new schools aimed not a beauty at all but as the development of a cult of ugliness. Important authorities have claimed that from 1913 to the present day the insurgents have produced no great art. True or false, that is a matter of opinion, but there is no question they have done a great service, perhaps unwittingly, and even if the final benefits are not yet in view.

The revolution was due. To a large degree conventional art had become nauseously saccharine. The high sugar content was inducing gangrene, and the acid of the new thought was needed to clean off the corruption so healthy growth might resume. The cauterization, to some, seems still unfinished and many others contend the current turmoil in the art world stems from over-application of the acid. Of course, prolonged use of a cautery will not build health. Some invigorating treatment must follow. But even those who feel the present trend is not invigorating will realize that if not now here the constructive period must arrive when conditions permit. After all, from 1913 to now is a brief span, historically, and unity in the art field today is too much to expect.

But let us leave the broad revolutionary aspect for a moment and consider the splinter ISM's spawned by the revolt and their concentration on details of the ritual while neglecting, possibly, the sublimity of the truth as a whole! They closely

resemble religious schisms where new cults are germinated from nothing more than the meaning of a word or a canonical phrase, and like easily founded religious cults, the splinter ISM's enjoy a rather abbreviated life span, or they convert only a limited number of believers. Even though the mortality rate of such groups is high, others are invented to replace those deceased. It is likely we shall always have the ISM's and cults with us. However, as long as the general public is to be the final arbiter in art, and despite the artists' protests, it would seem conventional, or realistic art will remain with us.

The high mortality rate is easily explained. ISM's are good examples of those who restrict themselves unnecessarily—who have but a single string to their bow. With their reduced arsenal they cannot compete indefinitely with fellow athletes who enjoy all the facilities. Art, like life, is an assemblage of a million conditions, and the wise man deprives himself of no tools that might help him in his work. We can't build a life or a philosophy on a single thought or a negative premise.

But all ISM's have their good points. Their *raison d'etre* is worthy. Suppose we take the lesson they teach—not any single one alone, but all of them, restrict ourselves in no way, grasp every advantage that the good Lord offers, and work like a beaver—and maybe someday we'll be able to turn out a rather decent picture.

Thoughts On Pictures Versus Art

Occasionally my conservative artist friends urge me to indite a message in dispraise of non-realistic painting.

Let me cogitate.

Art applied to flat surfaces like canvas and paper is divided into two categories. It must be either pictorial or decorative, for such art has no other function. Each category serves a valuable purpose in entertaining the human eye.

A picture, according to the dictionary, is "a scene", "a visible image", "a likeness", or a "vivid description"—in other words, an understandable representation of a recognizable thing. A picture is a complete entity in itself and in the process of painting it the artist's interest need not extend beyond the rim of its frame.

Decoration, or design, on the other hand, is an added bonus, applied to something that already has its own basic value, perhaps utilitarian or functional. The design, or decoration is always subordinate to the original purpose of the thing or structure which supports it. The design may include naturalistic representation, as in a mural painting; it may consist of conventionalized representations of known things such as acanthus leaf capitals or egg-and-dart moldings; it may take the form of

otherwise meaningless geometric lines or shapes, or of color arrangements; or it may embrace nothing more than a studied arrangement of the various parts of the object itself. If naturalistic depictions are included they must be considered as units that help the overall pattern. They must never outvie in importance the full compositions of which they are parts.

These two factors, picture value and design value, should be kept clearly in mind when any work of art is analyzed.

Today great conflict prevails in the combined ranks of easel painters and the probably more numerous non-art-producing authorities who somehow have affixed themselves to the art structure as to what's right or permissible in the compilation of a picture. At the moment, the group favoring non-realism seems to hold the upper hand.

Now, getting back to the difference between pictures and designs, let me repeat the reminder that, in its own sphere, either can be extremely appealing and valuable. Certainly it would be unreasonable to deny anyone the right to produce as he pleases in either field, provided his intent is honest and constructive. But somehow a feeling seems to have developed, as it frequently does develop with zealots in any cause, that if a condition is right or desirable, all differing conditions are wrong or undesirable. Specifically, those who favor academic art, in the main are opposed to Abstractionism in painting, while the Abstractionist forces, by and large, seem actually to despise pictorial naturalism. Unfair intolerance, anywhere, is intolerable, though it must be noted, in passing, those who like to call themselves the avant garde, being the newcomers and therefore more zealous, and being also in the saddle, are particularly perverse—which fact shows itself in the almost complete exclusion of traditional-style paintings from important and nominally "open" competitive exhibitions. Freedom to express oneself does not include the privilege of dictating to others as to what they may or may not paint, approve or disapprove, like or dislike. Perhaps, in view of the seeming incompatibility of temperaments (if not of views) of the two groups, it might be advisable simply to accept the fact of unalterably opposed factions and require each to function and exhibit independently of the others—for under present conditions it is not feasible to hold satisfactory exhibitions that honestly represent both points of view.

What I have to say here about painting applies of course in principle to sculpture and other branches of the visual arts. Painting is used simply as an example. However, my real aim is to emphasize the fundamental difference between pictorial and decorative painting. I feel this difference is the nub of the whole matter—the irreconcilability of viewpoint between the two great art forces today—and that its discussion might tend to clear up the misunderstanding. The plain fact is that painted

"abstractions," of their frequently acknowledged beauty and value, they are not *pictures,* and they should not be used as pictures. In my home I have certain walls papered in exquisite, semi-abstract, modern design. I could take rectangles of this paper, frame them, and distribute them as "pictures." Actually they would be as artistic as original paintings or prints produced by the artist-creators of the paper. I doubt, however, that anyone would approve, although such possible action in reality would be as reasonable as framing painted abstractions and calling them pictures.

Personally I prefer to paint in the naturalistic manner. Though it is generally assumed, as already indicated, an academician or an abstractionist must necessarily dislike the product of the other. I contend I have great admiration for much modern design and of certain abstract paintings (but only as design). I have no antipathy for "modern" painters, and I should dislike seeing restrictions placed on their prerogatives.

My only demand is they extend the same freedom to my "traditionalist" fellows—a freedom which, at the present time, is being suppressed.

Evolution Versus Revolution

Today we frequently run across the unflattering term "reactionary," so frequently in fact it is getting to be annoying; for it is apparent a reactionary is meant to be someone like myself, a conservative. Frankly, I'm proud of being a conservative.

That there is such a word as conservative seems to have been forgotten by many "progressive" writers on art who must consider it a synonym for reactionary. The latter at any rate is the term they regularly apply to those who disagree with them. The switch seems to be intentional.

Conservative is a perfectly honorable word and should need no defense, even though at the moment it is an opprobrious term to those whose thought-patterns are imposed upon them. To conserve means to *save.* A conservative is one who wants to *save something.* Is there anything decadent in that?

Art is just one facet of the whole picture of civilization, so in discussing conservatism we may include any details of our life. A conservative is one who wants to save the benefits bequeathed by the past. That does not mean he wants to return to the past, but it does mean he feels an honorable past can be used as a springboard for a glorious future. The conservative believes in orderly growth, believes in change when that change implies improvement or the promise of improvement. He believes in change by evolution rather than through revolution. He knows change is inevitable and desirable, but that not

all change is good. Change can spell retrogression as easily as progress. A conservative is a sensible realist who understands all undertakings involve risk as well as possible profit; he is one who seeks a reasonable assurance of a good landing place before he jumps into space.

Someone has said a conservative is one who knows he himself will have to pay for his own errors of judgement. In the present instance he will pay with the loss of the way of life his fathers built. He may feel he owes to the generation following him the heritage he receives from those who have gone before. Of course, there are many ways of life, many cultures. Ours is the civilization of Western Europe, or an extension of it. It has not been a perfect civilization, but for us it has worked out reasonably well, certainly as well as any other civilization. I doubt many Americans would care to exchange it for a Persian or a Siamese, a Chinese or a Russian culture—and this is not offered as an invidious comparison. Those cultures may be best for the people within their influence, but an American should have a right to prefer his own *modus vivendi* just as a Siamese was granted the right to prefer his.

I have no use for reactionaries. I never had any use for Fascists either, but I like even less the individuals, who use the name so glibly to describe those they don't like. My observations have led me to believe the name-callers themselves are undesirable. Strangely, I feel much the same about those who underline reactionary. I don't trust them.

So it is not surprising that the art arena is rife with discussions of "reactionary versus conservative."

It might be said that painting and sculpture have but a single purpose—to express themselves through VISION: in other words to be seen. The conservative artist is interested in saving the basic principles that have governed the production of art over the centuries. These principles include:

ABILITY TO DRAW ACCURATELY. As Michael-angelo said, "Drawing is the foundation of all the arts." No one can become a great artist without an ability to draw.

KNOWLEDGE OF THE SCIENCE OF COLOR.

AN UNDERSTANDING OF THE RULES OF PERSPECTIVE.

AN UNDERSTANDING OF CHIAROSCURO, OR LIGHT AND SHADOW.

A KNOWLEDGE OF DESIGN.

The purpose of art is to create a thing of beauty; to convey a thought or message of some kind; or to provide inspiration to someone.

By "art" I refer to drawing, painting or sculpture. If one is unable to subscribe to at least one of these qualifications his work has no value.

Since before the beginning of civilization, man has tried to draw—principally to draw pictures of himself. As he became more dexterous, his constant aim has been the ability to portray a photographic likeness of himself. In more recent years he has advanced beyond that. He has become so facile that now, certain ones have decided to throw overboard all the knowledge accumulated over the centuries and start anew.

The conservative artist desires to take advantage of the struggles of the past and the lessons it teaches and, building on that, go forward to an interesting and creative future.

Self Education

A young man asked Mozart how to compose a symphony. Mozart said: "You are a very young man—why not begin with something simpler?" The aspirant urged: "You composed symphonies when you were only ten years old." "True," replied Mozart, "but I didn't ask how."

Which emphasizes a point impressed upon me through many years of dealing with people—employees, students, artists and others needing or seeking instruction, and that is the most successful aspirants don't ask too many questions of others. They observe, and they interrogate themselves. One can often learn more by addressing inquiries to himself and personally reasoning out the answers than by burdening others with his difficulties. It is only human to value lightly that which we get for nothing or without effort. Somehow the gadget we construct with our own effort seems much more valuable than a similar one we receive as a present. So it is with knowledge— easily acquired, lightly esteemed, soon forgotten—but that which we dig out through our own calculations stays with us.

As I give demonstrations of watercolor painting about the country, I get an excellent opportunity to study human nature through the queries propounded during the ensuing question periods. One that impresses me is that many of the questions asked could be answered by the questioners themselves with very little contemplation. I am afraid those who so shun effort will not get far in the art field, which, incidentally, is no place for one afraid of work.

As someone has said: "Get *all* the *facts* before you, and the answer stares you in the face." My boss once told me: "only a fool asks questions he could answer himself." Experience has since taught me that the answers to many questions are easily

calculated from the facts at hand if one has the energy to look for them.

Habits are about the only servants that will work for you for nothing. Just get them established and they will operate even though you are going about in a trance. This works both ways, of course, good and bad, so you must be careful to encourage the good ones and suppress the bad.

A good habit is to develop an inquiring mind. From personal observations I can testify to its efficacy. One of the executives in our plant tells me that as he goes through the works observing the tasks being performed he says to himself, in the case of each, "What is being done here that is wrong or that could be improved?" This practice now operates for him without conscious thought and, workers being human, he finds much to improve when he answers, also instinctively, his own questions. That executive is responsible for more improvements and fewer complaints in his department than anywhere else in the factory.

The art student's inquiring mind can cover such questions as: "Why does that painter include that feature in his composition?"—"How does he operate to get such an effect?"—"What mixtures were used to achieve that hue?"

Then, knowing success is never accidental, that every part of a painting was planned by an intelligent person, he will be well repaid for working out the answer himself from the evidence at hand. Not only will he get the needed information, but he will also strengthen his system of automatic calculation. You will be astonished to learn how rapidly the information procurement habit will function, with a little practice.

I cannot too strongly emphasize the difference between learning and being taught. Those who must be taught never go far. It is the one who learns who rises to the top.

Naturally you must ask questions occasionally, but this should be done only as a last resort and after an appeal to your own reason fails to give the answer. In a new field we must seek enlightenment and sensible questions can sometimes save much time, but let us remember that a *word* to the wise is sufficient. Let us get to understand the principle of the situation with our questions—reason should uncover the self-evident details. Every learner should be the supervisor of his own education, or otherwise he is merely being indoctrinated. His questions should be phrased to teach him precisely what he wants to know, without his being forced to wade through a lot of extraneous and unimportant addenda.

Teachers Of Painting

Frequent requests to recommend artists as teachers remind me there are two kinds of teachers of art, which you should know also in case you plan to enroll with one.

There are serious teachers who sincerely desire to make capable, well-rounded, resourceful artists of their pupils, and there are those who enter the teaching business primarily to make money or to make of themselves the object of an adulating group. My observations convince me the latter type unfortunately outnumbers the former by far, in the realm of free-lance teaching.

Let us consider first these opportunistic teachers—though that may be too strong a term, for they really give the customer what he wants. Their classes are made up largely of students no longer young—and preponderantly female. In the teacher's defense it must be stated that few of these learners are willing or able to devote the time required to develop a worthwhile artist. The gratification of their own egos seem to be a governing incentive. They hope, apparently, with a few easy lessons they will be able to turn out an acceptable picture which, after being clearly signed, can be framed and hung in a prominent position. For this they are prepared to pay substantial sums per lesson. Many are wives of affluent men.

To be successful in this particular field, the teacher must fall in with his pupil's desires and, being human, most of them readily do, for such work is easy and profitable. First the teacher chooses subjects that have little detail, require no drawing, and can be registered in large masses—fields of grass, trees, clouds, distant hills and the like. Usually he works out a simple, appealing color formula, imposes it upon his class, and gives them simple but definite rules for the painting of each component part—instead of teaching them to think for themselves and to work out their own combinations. He doesn't hesitate to sit down with each student, correct the student's errors, and paint in, himself, whole areas of the work. Later he adds the finishing touches that gives the picture sparkle.

All this of course delights the neophytes, who consider their progress remarkable, which it is, and due to their own talent, which it is not. And they are also inclined to believe that a teacher who can bring out this hitherto unsuspected genius must necessarily be the world's most brilliant artist. They regularly so proclaim, and they also buy his pictures, for the same reason. Teachers with personal classes are usually successful sellers of paintings.

Unfortunately for the student, however, after he leaves his instructor and embarks on his own, he finds himself at sea and totally unable to paint. He now learns that about eighty percent of each of the pictures he signed was the result of his teacher's

knowledge and direction and not his own talent.

I am reminded here there is still a third kind of instructor whom I should describe before reaching the conscientious teacher. He is the one who takes advantage of the present-day emphasis on abstract art. Anyone of course can paint abstractions of a kind, so his method is to allow students to doodle as they please, so they may "arrive" overnight. His real task is to teach the lingo or double-talk that goes with this sort of rubbish and which purports to prove that the product is of transcendental importance. As the big lie, oft repeated, eventually convinces those who can't think for themselves, a large number of Americans have fallen for this rot. I consider these teachers charlatans.

On the other hand, the dedicated, free-lance teacher has a difficult task. The serious student who really plans an art career realizes years of study are required. He is usually young and unequipped to toss money about casually. If feasible he enrolls in a recognized institution for art teaching, for that is unquestionably the best place for earnest and prolonged study. However there *are* serious free-lance teachers if one is willing to seek them. Frequently they teach artists already competent who feel the need of individual direction by a master.

In working under a serious, dedicated teacher you will not make the flashy progress the easy-method instructor offers, but you will learn the fundamentals of the business that later will enable you to become a real artist in your own right.

So if you are considering the study or art, first search your own mind and then choose your teacher accordingly.

The Colleges

We all know there is something wrong with our national education system, and we should know that *something* is not entirely the result of accident.

Like many newspapers, college art departments, generally ape the Art Establishment line. Except the artists who paint in the traditional way and the general public nearly everyone else toes the line as well. The answer to "Why?" is easy to guess. In the main, the only group that is thoroughly endowed with a knowledge of art production, almost without exception, is that of the conservative artists. Their training calls for many years of study and practice and because of this long training but few artists of note have had time or the desire for a complete program of college training. Without college degrees, they are not generally permitted to teach art in colleges, regardless of their superior ability. As one wit quipped, "Even Michelangelo couldn't get a teaching job in an American college." It would

be hard to find earned academic titles among any of the great artists of the past or present. So the best teachers are found in private art schools which themselves are not allowed to bestow academic degrees.

Fine art courses in colleges for the most part are little more than art appreciation courses. One learns about the history of art, the art jargon, how to judge art according to the Establishment standards and the like, but little or nothing about how to paint pictures. In fact, the avant-gardists' insistence that each artist's work emerge from his very own soul, free of influence by others, forces them to acknowledge that "progressive" art cannot be *taught.* The function of the teacher is to bring out the students' original conceptions and not to show how pictures *should* be painted. In view of this laudable aim it is surprising to note that far less originality is shown in contemporary "progressive" art than in that of the traditional artists. All of the Establishment-type art work can be assigned to a very few categories.

I cannot name one outstanding and capable artist who developed his ability from a college art course. The students graduate and receive their degrees and are then ready to teach, which many of them do, in colleges, because they have the necessary academic degree. I recall a newly-elected president of one of the country's foremost art colleges revealing that sixty four percent of the instructors were graduates of that very institution.

The result of the system described above is that the specialized art schools have the best teachers and turn out the really capable, thoroughly trained artists, while many colleges have only degree-holding but often incompetent "artists" and graduate relatively few students of importance.

Naturally the typical colleges specialize in abstract or eccentric art as these fields require little skill to enter. The privately-run schools specializing in art teach the hard-to-learn fundamentals—so here we have two lines of endeavor running along divergent paths with little connection between them.

The educational fraternity places great stress upon theory, and this is as it should be, for all progressive and all movements must begin with theories. But all but the simplest theories contain "bugs" that must be taken out before the theory can be called sound—and to take them out the theories must be tested in practice and then modified to overcome the almost-certain-to-be-found objections. Every practical thinker and doer knows this. Unsound theories are not acceptable. They must be made sound or discarded. This is the method followed by industry. There, half-baked ideas are shown to be what they are. Contrast this with the practice in many of our institutions of learning. There a theory is conceived and expressed—on finance, government, foreign relations, art or what not.

Appearing plausible to those in charge, the theory is then accepted as sound and without any attempt being made to find the inevitable bugs, other theories are built upon it, and newer theories upon the new ones and so ad infinitum. This is one of the things wrong with our educational system. It explains the art systems in our colleges.

Most of the members of the Art Establishment hold college degrees so it is not difficult to understand the connection between college-taught "art" and the kind sponsored by the Establishment.

Almost everyone has respect for college degrees, so it is only natural for most of us, including degree-holding art museum directors, to look to the Art Establishment instinctively for direction. But government agencies theoretically might be expected to show less bias, artistically, though actually they also swing automatically toward the same magnetic pole— virtually never to the national associations of the great artists of the country. I refer to the National Academy of Design, the National Sculpture Society, the National Society of Mural Painters, the American Watercolor Society, Audubon Artists, Inc., Allied Artists of America, American Artists Professional League, etc. Relatively few of the members of these associations can boast of doctorates or degrees of any kind, so the gulf between the art producers and the art theorists and the unlikelihood of their ever seeing eye to eye can easily be imagined.

A Remaining Frontier Of American Cultural Expansion — Art

Artists who paint the pictures seen on museum and gallery walls all receive, at frequent intervals, greetings such as this: "So you're an artist! What do you do for a living?"

Well, that's a good question, and it points up one of the strangest anomalies in our entire field of living today, for the artist shares with the scientist, the industrialist, the writer, the thinker, the agriculturist, and the politician, the distinction of being one of the few forces that control our destinies and our everyday behavior—yet he is the country's forgotten man so far as recognition and reward are concerned.

This statement may come as a surprise to most readers, for the artist is much in the news. Yet the public knows little about the real structure of the American art business. Why? Probably because the manifestations of the work of artists are so numerous and commonplace they are just taken for granted,

like the trees and rocks about us. People just assume they were always there, and they never conceive of existence without them.

But excepting the rocks and trees, and the like, the water and the animal life, everything with which we are familiar appears as it does because of the efforts of certain artists. The appearance of everything constructed by man, from safety pins to writing paper, from bedroom furniture to skyscrapers, to ocean liners and giant airplanes, everything, EVERYTHING, is as you see it because some artist willed it so.

Today, no one could persuade our discriminating buying public to purchase anything unless it had first been touched by the artist's magic wand that gives it the wanted appearance.

The lines of the old Model "T" Ford were determined by engineers or by the mechanics who put it together. It had little

The Patient One
22 x 27½ inches 1970

Collection of Mr. & Mrs. W. A. Michaelis
Valley Center, Kansas

that could be called design. It sold because it had no competition, but at present, appearance is one of the greatest selling points in automobile or any other kind of distribution.

Well, you may wonder about the implied connection between gallery paintings and automobile splendor. That connection is simple. In the sense of our present discussion there are, roughly, three kinds of artists: 1. Industrial designers—2. Commercial artists—3. Fine art, or creative painters and sculptors.

The industrial designer works at the appearance of every manufactured or constructed thing. This field also includes the architect. Great thought is lavished upon the appearance of every detail of every item, and great sums are paid for results, for despite the utilitarian virtues of the product, its sales success, in today's market, depends upon its outward design.

The commercial artist is responsible for the appearance of everything printed upon paper—the magazine cover, the illustrations and advertisments inside, and even the layout of the pages, the size of the sheet, and the kinds of paper and type employed. His province includes the comparable details in books and newspapers, the appearance of packaged items, of wrapping paper, and of everything under the sun which bears the impress of printer's ink.

Industrial designers and commercial artists are well paid, for they work in the divisions of activities where large amounts of money can be handled, so payment for design can come out of earnings.

The fine art painter or sculptor paints pictures or he models in clay—among other things. No one tells him what to do, for he is a creator, and he must follow where his conscience directs. He is of the genius type, and the function of all geniuses or creative workers is to search for new truths and new methods. His course is not predetermined. That course is dictated by new evidence as it appears. And for this reason possibly—because his real function is not generally understood or his accomplishments are not advertised—he is seldom given a serious thought by the practical-minded and progress-conscious public.

But the creative artist is probably the most important of all in the art field, for he is the fount from which all later production develops. He is like the researcher in pure science who discovers, let us say, the formula for penicillin. Having discovered penicillin, Dr. Fleming, himself, could never have delivered it to an ailing public. The efforts of applied science workers, the chemical engineers, the great drug manufacturing houses, also are required to develop the finished product at a reasonable price. Tremendous sums of money are involved in its distribution, and regular incomes are received by all the workers. But in comparable situations it is quite possible the pure-scientist inventor or discoverer could receive no

Old Man In A Hurry

We often hear reference to an "old man in a hurry", meaning one who realizes his days are numbered and who wants to deliver what he owes to the world while time permits.

As he looks back over his life span he is shamed by the little value he and others placed on time in their younger days when they felt that life had no end and there was always time ahead to carry out necessary duties.

Perhaps if youth could put itself in the old man's place a valuable lesson could be learned.

Looking forward, in early days, seventy or eighty years seemed like an eon, but looking backward seventy or eighty years, from old age, one is astonished at the actual brevity of human life. From such a point in life fifty years in retrospect seems like yesterday.

One of the appalling thoughts that comes to an old person is the enormous amount of time all of us have wasted in non-productive activities. To name a single one, of many that could be offered, there is our over-indulgence in the viewing all kinds of sports events. None of these events produce anything that could be called usable. Spectators go into a frenzy rooting for their favorite team, yet what does it matter to humanity in general whether Team A or Team B wins the pennant?

Now I am a strong believer in athletics, but in my opinion the real value of athletics lies in the exercise it gives one, rather than in their spectator value. Nor do I advocate the discontinuance of sport watching. But I think we could get along with less of it. Certainly such activity produces nothing tangible for humanity. We need more production of things the world can use—for the lack of useful production is the cause of more misery in the world than any other factor.

The old man knows the truth of that, and he knows productive work can be more enjoyable than simply *watching others* in competition. How many of us can remember the names of the sports heroes of yesteryear? Or who played in the World Series two years ago?

A friend of mine died a short time ago at age eighty-seven. But three years ago he began the writing of an historical essay which turned out to be an important book. Despite the handicap of age and the difficulty of the work, he created more pleasure for himself as well as something usable for the world than many younger persons would acquire by joining a golf-tourney gallery.

Another friend, a professional deep-sea and scuba diver, works for the government as a marine zoologist, so his vocation and avocation are the same. But he also has another hobby. With a miniature factory in his home basement he turns out works of art in precious woods. Another is a

columnist for a large newspaper who, on her own time, writes and publishes biographical monographs.

What I have said about sports applies equally to many other endeavors which, over-indulged, can result in wasting of time: television watching, recreation in general, gambling, pointless excursioning and the like.

My suggestion is that we use our time, or a large part of it, in following a productive rather than unproductive pleasure, without waiting until old age drives home the point of the advice.

As Robert Herrick said, about three hundred years ago:
Gather ye rosebuds while ye may,
Old time is still a–flying,
And that same flower that smiles today
Tomorrow will be dying.

Success

An old saying avers that any person who goes through life in a state of poverty or failure is deserving of his fate.

Success in any endeavor comes from planning and subsequent action. And the big secret is concentration—concentration on the job at hand, whether large, small, or one's overall aim in life.

We all have desires, but many of us have no goal toward which we are willing to strive. The universal desire is to accumulate riches, but many wishers exert themselves no further than to *hope* that through some stroke of luck or magic formula those riches will be attained. Study of life in general shows the chance of financial success that way is only one in many thousands.

Observe the activities of the average non-starter—the one who *hopes* to become rich. Does he concentrate? He does not. Observe his obsession with time-consuming, unimportant matters, such as spending days as a unit of a golf-tourney gallery or "shooting the breeze," etc. Incidentally, pointless conversation is probably the most expensive commodity known to man. One learns nothing while talking and, even in the case of necessary discussion, action can't begin until the conversation stops. Of course everyone needs an avocation or alternate diversion as well as a vocation if only as a foil for his intense concentration on the overall goal. But for the successful ones the avocation or pastime is just that and is never pursued as an end in itself.

The really successful persons are those who produce for humanity in general something worth more than they receive—even though their personal receipts may be substantial. The great writers, composers, engineers, inventors and

the like—workers like Thomas Edison, Sir Alexander Fleming, George Washington Carver, Marie Curie and their breed are such individuals. Though most fare well, pecuniarily, the benefits they confer upon the world are immeasurable.

But we don't all have to covet the stature of these great ones. If we can but contribute a little more to the world than we take from it, in any pursuit, we are successful, and society is likely to pay us well for it. Of one thing we can be sure, the world will not pay anything to anyone for hours spent in idle pastimes.

Temple of Diana, Nimes
22 x 27 inches 1955

Collection of Anna Hyatt Huntington
Redding Ridge, Connecticut

Outstanding characteristics of successful men and women are: their ability to concentrate, their habit of working toward their goals during all waking hours, and *the enjoyment they derive from their work.* They wouldn't trade that enjoyment for all the fun of baseball watching, card playing, gossiping and the like that the world can give.

Successful individuals are incessant workers. But others will say "That is drugery—I must have fun." And their idea of fun is getting away from work. But if one has *interest* in his work he will find in it greater fun and happiness than any kind of time wasting. It is just as easy to develop interest in an activity productive of value—value to others as well as self—as to be concerned with mere diversion. Through the former one can transport himself to heaven without both of them dying.

So if your main interest is in pastimes, it is not likely you are concentrating—planning, acting, and concentrating—and you are not going to become successful, financially or otherwise. And the additional truth is you don't deserve to.

Who Wins Art Prizes—And Why

Through many art society connections I receive numerous communications, oral and epistolary, suggesting cures for the real and imaginary ills of the art world. One subject quite commonly voiced refers to the awarding of prizes in competitive art exhibitions.

Example: certain artists whose work contributes greatly to the success of American merchandizing; leaders in their lines and included among the best paid in the country, say to me; "Why is it that illustrators and other commercial artists are seldom found in the lists of award winners? Surely these perfect technicians can paint as beautifully as anyone might demand, yet year after year the prizes go to others, and if not to the same artists repeatedly, then certainly to the same kinds of artists."

The answer to that question is quite simple. Artists win awards for no other reason than that they paint the kind of pictures juries like. And if other artists are really desirous of winning prizes, they must follow one of the only two courses open. Either they paint pictures that please the jurors, or they elect jurors who admire their particular brand of painting. It might sound logical for me to proclaim: "My pictures are good—therefore, any fair-minded juror *should* like them"—but if jurors do *not* like them I am simply pitting theory against fact, surely a common human failing—but I should know better.

Now when I state that prize-winners paint the kind of pictures jurors like, you may counter with the claim that such action is intellectual dishonesty, and of course the artist would

be dishonest where he deliberately to sacrifice his principles for cash. I doubt that often happens. The more plausible answer is that the jurors and winning artists had similar leanings in the beginning.

My commentator could assert that if a thing is good it is always and everywhere good, and there are no two ways about it; but he is wrong, and the repetition of that error is the basis of much misunderstanding. There is no such thing as absolute good. Everything is relative. A production is successful or good if it achieves the end for which it was designed, and may not be good at all if applied to another use. Certainly there are many different and laudable purposes for which pictures may be painted, and they must be handled differently as the purpose changes.

Suppose a certain subject is to be painted, let us say a ship at sea, which will be reviewed by these authorities:

 1 An advertising art director
 2 A commercial art gallery owner
 3 An art museum director
 4 A home-owner
 5 A sea captain
 6 An art reviewer
 7 The "man in the street"
 8 Another artist
 9 An exhibition jury

Surely no single painting would satisfy all. For this, eight different productions, or at least four or five, would be required. There is nothing unfair in this situation. Each individual would be justified in demanding his particular kind of picture, for each has a different ideal in mind.

The picture that would be "good" for the art director would not be "good" in the eyes of the museum director, or vice versa, but in neither case need there be any reflection upon its fundamental artistic worth.

Few easel painters have their work accepted by art directors, and easel painter juries will seldom approve commercial type compositions. There cannot fail to be great difference between the necessarily full statement of the illustrator's work and the necessarily reserved statement of the aesthetic painter's production. Both parties must understand and accept this truth. The illustrator should and will win the awards at an illustrator's show, and the aesthetic painter should and will win the awards at an open painting exhibition. Both the commercial man and the easel painter are equally necessary in our system, and stand on an equal footing, but neither can successfully enter the other's territory without changing his approach. There is, however, nothing to prevent the same individual artist's being a commercial painter today and an easel painter tonight, or tomorrow provided he is

capable of entertaining two points of view.

In this discussion the commercial artist has been used as an example of a distinct type. But the statements allude equally to other classes or artists as they are related to the aesthetic painter.

So let us repeat then that if the individual desires recognition by the group—any group—he must please the group. He would be unrealistic to demand that the group conform to his personal specifications.

But if he still doesn't understand the difference between his own work and that of the group which rejects him, he might temporarily set aside his present convictions and in a receptive frame of mind explore the situation more diligently. He is not bound to like or approve the answer he brings forth, but he will learn what the answer is.

Fame

Some years ago in the Vose Galleries of Boston, I was handed a quarter-sheet watercolor painting of three trees, done in infantile style, and was told it was an original Winslow Homer—the only one Vose could find available in the country for purchase by his client. I remarked that it must have been painted during Homer's pre-teenage period, but I was not surprised to learn the owner was asking $4500 as its price.

This suggests a subject that I have long pondered, namely the nature, cause and value of fame.

Fame can be acquired in three ways:
1 Through real accomplishment.
2 Through paid publicity or sponsorship by an influential interested party, regardless of the subject's worthiness.
3 Through a combination of 1 and 2.

In most fields of endeavor actual qualifying achievement is required, that is, in fields where performance can be *measured.* In golfing, for instance, where fame and fifty thousand dollar awards go together, there can be no question as to who holed out in the fewest strokes, while in the realm of medicine the value of a newly discovered drug can be definitely checked, to mention only two examples. But there are other fields in which we have indefinite standards, or none at all, for judging merit, and in these, one becomes famous by opinion—by the opinion of the Establishment, by public opinion engendered by the Establishment or by private, commercial publicity. Politics, the performing arts, music, painting and sculpture belong in these latter categories. The fact that in some divisions numerous members of the same family become famous indicates that genius is not the governing

factor, for genius just doesn't strike that often in that way.

In the world of the visual arts: painting, sculpture and drawing, "fame" is unquestionably manipulated to a much greater degree than in any of the others, for here there are no accepted standards whatever. The opinion of the general public is not even considered. In this division art, thought and opinion are definitely controlled. The people are told by the art hierarchy what they may acceptably think and like, and artists are told what they must paint if they expect their work to be shown in most national exhibitions.

The latter half of this condition is, of course, just in principle, for the function of jurors is to make such decisions, and there could be no complaint if this control were exercised by the practicing art fraternity itself, but surprisingly, nearly all the members of the art hierarchy are non-artists; they are museum directors, art writers and "informed laymen", as they like to call themselves. This represents a condition that, presumably, could not prevail in any other branch of work. Proof of the fallibility of the hierarchy is the fact that over the past fifty years at least the names of many of those who have been touted as "greats" cannot now even be recalled.

In the field of the visual arts virtually anyone can be made "famous" whether he has talent or not, by publicity alone. Any number of examples to prove this assertion can be made. The only requisite is to arouse the interest of the hierarchy members directly or to arouse their interest indirectly through the efforts of a clever and sufficiently financed publicity agent. This is not particularly difficult if the artist's style is *different*. The difference may even border on the abnormal or worse.

"Fame", today, simply means to have an "angle" and to have one's name associated with it and mentioned repeatedly in print or over the air; a simple achievement for a publicist.

Subversive propagandists have demonstrated conclusively that the "big lie" can be sold, as truth, to the multitude—and this task is simplified when some half truths are available; when one need not lie, exactly, but has only to exaggerate. Better still, in glorifying an artist the publicist may find it necessary to dwell only upon one side of his character for, after all, virtually all propaganda is simply a matter of reporting one side of a situation and glossing over the other.

The process is much the same as that of making a saint (though it is to be assumed that all saints possessed great virtue). When one attains sainthood we are told to revere him and henceforth, perhaps without ever inquiring the reason for his elevation, we are to accept him as one of the great, never questioning his right to adoration. And if you think that wire-pulling and politics never enter canonization procedures you may have greater naivete' than is your due.

And so it is with famous artists. I recall hearing an

illustrated college lecture on the watercolors of John Marin. Of one painting the professor said: "This is an unusual example. Marin has drawn two dark lines down through the middle, dividing the picture into two parts and apparently destroying the composition. For several years I have studied this particular work to learn why he painted it thus, and I think I can grasp the answer." This demonstrates we can convince ourselves of anything if we so desire. In my opinion, the real answer to the professor's inquiry is that the work is just a poor painting that should have reached the waste basket immediately after completion.

Once fame is established, deservedly or otherwise, an artist's total output becomes famous also. The people will see genius in everything he produces or has produced and, as in the case of the Winslow Homer, will pay fantastic prices for even his studio scrapings.

Thoughts On Picture Prices

Are you an artist with a studio full of paintings you consider unsuitable for serious competitive showing, yet are undecided on how to dispose of them?

The answer is to become famous—through the other pictures you have painted or through other outstanding achievements—or to become infamous from some horrendous behavior. Then all your pictures will sell, at prices you never considered obtainable, for the wand of fame not only exalts the man but all his appurtenances as well. Prices for subsequent work rise though the quality may remain static; the prices may even approach those of old masters.

From England we hear of still another chimpanzee, Cindy-Lou, who holds the paint brush between her toes to create masterpieces. Her fourteen serious paintings, made recently, will be auctioned soon. "Incredible", says painter Roy Reynolds, a descendant of Sir Joshua. "If her paintings were exhibited in London they would fetch up to sixty pounds apiece." So, judging the future by the past and remembering her already acquired fame, we may assume that anything Cindy-Lou paints henceforth, academic or abstract, good, or bad, will be snatched up by eager collectors. How many artists of the genus homo sapiens have achieved such world wide attention?

By nature we see what we want to see, and if we are told repeatedly a certain artist and his product are famous, we scrutinize his work until we are satisfied we can detect the fame-making ingredient. Virtually anyone can become "famous" if he chooses the right publicity agent and can afford to buy the services. Certainly this accounts for the "fame" of a good many

A Window in Spain 1964

contemporary artists. Of course the misbeliefs will be clarified in the long run, but that sometimes entails a lengthy process. It required over a century and a half to properly appraise Parson Weems' saccharine word-portrait of George Washington; the majority of our people still believe that the "Boston Massacre" was a massacre, and even at this late date may contend that the world is flat. Once one has been efficiently publicized the image created can be changed only by counter-publicity.

There are two kinds of prices paid for paintings: collectors' prices and work-of-art prices. We must keep this differentiation in mind, for unless one follows the pertinent one of the two standards when evaluating a given piece his appraisal is worthless. Collector's prices run much higher than work-of-art prices. Take any of the old masters or not-so-old masters, for example. Their figures today are astronomical in comparison with the prices actually paid the artists, though the artistic qualities of

the works have not changed. What has changed is art opinion and art opinion can be and often is manipulated. Time is usually, but not always, the arbiter that separates the chaff from the grain. It is clear some of the presently high-priced "masters", especially those of less than a century in age, will someday be reduced in standing, as some now unrecognized will be elevated.

Personally, I could have no interest in procuring pictures solely because of the artist's name. Buying one, as I do occasionally, I consider only its artistic value. True, the work of an outstanding artist is more likely to be good than that of an unknown, but this is not necessarily so. Many unrecognized artists on the way up produce really fine art.

Paintings by artists not yet known are usually chosen for their inherent attractiveness as well as their artistic qualities, but the typical collector will often buy any painting by his selected artist. Many name pictures are poor examples that would pass unnoticed without the signature. Collector buying might sometimes be called "prestige" buying. I have in mind a wealthy friend's museum-like home filled with expensive name pictures. On the other hand I can visualize the homes of many others, of modest income, which, as decorative examples, outrank the first.

The "safe-playing" collector buys "by the chart", and for that he usually pays higher prices. He resembles the stock trader who deals only in "glamor" stocks. Those in the know find real worth at more reasonable prices. Naturally a special knowledge is required for buying anything profitably, and such knowledge is not acquired just by wishing for it. But sometimes we can use the knowledge and advice of others.

So, to repeat, let us remember the artistic and collector values of a painting may or may not be equal, but in any case we as individuals may set our own evaluations.

Artistic Abnegation

We are all familiar with occupational diseases—Silicosis, Housemaid's Knee, Painter's Colic and the Bends. Allow me to add another, universally recognized, but never before dignified with a name. Until a better one comes along, let us call it *Artistic Abnegation.*

I am fortunate in numbering among my acquaintances many artists: famous artists, notable artists, average artists, and others. I will almost wager that no one else is on speaking terms with a greater number of painters. In addition, I rub elbows with many others in fields cultural, educational, and industrial. These facts in themselves do not constitute a distinction—presumably bill collectors or bookies spread their associations over broader ground—but the information is offered to establish the premise that I know what I am talking

about when I compare artists with workers in other fields.

The modesty or humility of easel painters is amazing. Perhaps these terms are inaccurate. These artists may be simply "subdued". Anyway, I observe nationally-known painters kowtowing to newspaper critics, hoping a few crumbs of praise will fall their way. I sit in at meetings of other artists who abjectly consider themselves honored and their cause advanced by the inclusion in their programs of individuals in the public eye. I see artists electing, on the absurd and obsequious theory that certain laymen know better than the artists themselves what is good or bad in a picture, a jury of non-artist museum-directors, gallery owners and art critics, who will later exclude from exhibition the work of the very artists who elected them. I see good artists fawning before second-rate gallery owners. I know of many artists, including yours truly, who donate their services and their pictures to all sorts of projects and causes for no greater payment than the few bits of publicity they receive. In various ways I notice artists of stature standing hat in hand before self-appointed commissars of the art business.

All this because the artist acknowledges himself to be inferior to these others—or more accurately perhaps because he considers them superior—and there is a difference there!

But the astonishing thing about this whole business is that, considering actual achievement, these artists have many times the standing of those whose favors they seek. They have spent many years in study to develop their innate talent and to attain their high standing. Of the whole group under discussion they alone contribute to the lasting treasures of the world. Their accomplishments will be known for generations after the names of the others are forgotten. Under such circumstances they might almost be excused if they were to snub the rest of the world—an attitude not entirely unknown in days when art was a revered profession.

Why don't artists assert themselves? I have often wondered. The answer seems to be economic. All the satellites of the system—the scribes, the museum directors, the art supply people, the framemakers, the draymen and the rest, are well paid for their work—deservingly, of course, but the poor producing artist, who supports the whole structure, lives on a relatively close-to-starvation basis. As my friend Pappy Hurlock says: "They ain't got it so good." In the fields of literature, poetry and music, inexpensive reproductions make multiplication of one's effort possible, but there has seldom been any great demand for necessarily expensive reproductions of fine-art paintings. And I suppose there is something to the belief that an empty belly inspires no fortitude, or, as Henry Lawson said, "A man's an awful coward when his pants begin to go."

So would it be out of order to suggest that artists fill their bellies with the meat that prompts carnivorae to roar, that they man their juries with artists only, that they ignore the opinions of the non-artist reviewers, that they avoid dictation by dealers and museum directors, and that in all ways they retake control of the art business and substitute leadership for servility? Thus we might add to the list of controlled ailments—smallpox, diphtheria, etc.—the latest to be analyzed: *Artistic Abnegation.*

To Organize An Art Society

Every aspiring artist should join at least one art association—and if there is none in the vicinity he should meet with other artists to establish one, for an individual improves himself by associating with, learning from and competing against others. He must deal with others to measure his own potential. All progress develops from community action. There could have been no Rembrandt without the great Dutch School, nor a Michelangelo, had there been no Renaissance—and there can be little advancement for the individual American artist unless he associates with others in reciprocatory pace setting.

Some of the advantages of art society membership are these:

1 The society becomes listed in art directories, and through his organization the artist is recognized as a regular member of the art fraternity of the country. His name finds its way into various mailing lists and he receives news of art world happenings. Notices of coming events, data on sources of supply and other pertinent information.

2 With his fellow members he can consider the conditions that apply to his particular vicinity and take steps to improve them. As an unattached artist, unless very well known, his voice may mean little, but through his organization his utterances will receive serious attention.

3 With his fellow members also he can exchange ideas and methods, so that each gets the combined benefit of the knowledge and experience of all. Exhibitions, lectures, and discussions will aid not only the society, but the municipality of which it is a part. An art organization gives added cultural standing to any community.

To organize a society, any artist, alone or in collaboration with others, should first prepare a list of the names and

addresses of neighboring artists whose location or capabilities qualify them for membership. He then notifies each by mail or otherwise that the presence of that artist is requested. With the artists assembled at the appointed place, the originator of the movement takes the floor, addresses the group, states the purpose as fully as possible, asks for discussion and suggests that, with permission of the group, he will act as temporary chairman. He then presides in the usual way, thus assuring that the discussion shall be orderly, that only one speaks at a time, and that each shall have an opportunity to voice an opinion. The discussion, at this state, should be confined to the feasibility and desirability of the plan. When consideration of these points has proceded sufficiently to establish a general desire for its acceptance, the chairman should ask for a vote or call for a motion from the floor on this question: "Shall the assembled artists form an art association?" This vote can be taken by a call for "ayes" and "nays" or by a show of hands.

Assuming the majority favors the plan, the temporary chairman then states that a permanent administration must be established, and he asks for nominations for the presidency. Courtesy, of course, usually suggests that the organizer himself be offered that position, but in any case he calls for a ballot on the nominations tendered. A voice vote or a show of hands will suffice if only one person has been nominated, but a secret vote, on paper slips, may be advisable if more than one nomination is before the house. The successful candidate then assumes the chair, as the duly elected president. He asks for the nomination and election of a secretary and a treasurer. These three officers will then form the official administration until later action amplifies or changes it, and they assume charge of arrangements for dates of future meetings, etc., until such time as the society makes rulings as a body.

The president instructs the secretary to list the names and addresses of all those present, or those who are to be members. These artists are, then, the charter members of the association and are so recorded.

Certain other subjects are discussed, and the president appoints committees to assist in their development. These subjects include:

A. Name of the organization.
B. Its form of government. If by a Board of Directors, who, in addition to the regular officers, will form the Board?
C. Time of later meetings.
D. Amount of dues to be paid—when the fiscal year begins and ends—method of electing new members, etc.
E. Appointment of a committee to draw up a constitution and by-laws.

As for the name, it is always advisable to use a simple, descriptive title, such as "The Kensington Watercolor Association", "The Smithtown Paint and Clay Society", "The Doylesville Pen and Brush Club", or something of this nature. "Smart" or restrictive names, as exemplified by: "The Diligent Dozen" should be avoided, for while that might aptly describe the group at its inception it conceivably might not serve in later years. The title should allow for plenty of expansion and change in the organization.

The average dues of working art associations throughout the country today amounts to about $15.00 per annum. Some are as low as $5.00. Virtually none exceed $20.00. Immediately after a decision on dues is reached, the treasurer should send bills to all members.

After actual establishment of the society, activities might include:

a. The holding of meetings at given periods, where mutual assistance and any questions brought up by members can be discussed.

b. Arrangements for exhibitions, at least once a year—for lectures, conferences, public discussions, etc.

c. Subscription to several leading art periodicals, either as a society or through individual members. (Note that many art magazines run calendars of forthcoming exhibitions, competitions, free scholarships, etc. with brief descriptions—without cost to the advertiser).

d. Registry of the name and address of the society in art directories such as that issued by The American Federation of Arts.

e. Notification of local newspapers and radio stations of the establishment of the society, giving names of officers, etc.

Council Of American Artists Societies

There are two divisions in the field of the visual arts. On one side we have the artists themselves, who actually *produce* art—all the art there is—while on the other side we have what is called the Establishment, which consists, for the most part, of museum directors, critics, and most art magazine publishers. The Establishment controls art thought in this country, tells the public what to think, what to see and what to buy, in the matter of art, and dictates to the artists the kind of work he must

Ostensorium

Made of gold and platinum, embellished by diamonds and precious stones. It is 42 inches high, weighs twenty seven pounds.

produce if he expects to show his work in museum exhibitions or in government-sponsored exhibitions. Today the Establishment tells us, by inference at least, that contemporary art done in the representational style is not art at all and that the only art worth exhibiting is the extreme, avant garde material that is

seen on every hand. There is no question that this Establishment has great power, for it is backed by great financial resources, it is well organized, it controls many of the art publications, the members are well trained for their propagandic work, and they receive substantial salaries for carrying on that propaganda.

In the use of words, practicing artists are no match for the Establishment members, for the artists have spent most of their lives in learning to express themselves with paint or clay while the others have been acquiring a liberal college education and skill in polemics. Engaging in discussions with Establishment members or others agencies artists are under a further disadvantage, for they not only receive no pay for their time, but they must neglect their own work for the purpose.

Hardly any of the Establishment members are practicing artists. This situation, where a whole field of creative and skilled workers is dominated by beneficiaries of the system who themselves are not artists is unique. It would be difficult, if not impossible, to name another field where this unreasonable relationship would be permitted to prevail. Certainly no association of lawyers would allow non-lawyers to dictate legal procedure to them, nor would any organization of doctors permit laymen to tell them how to perform an appendectomy, for example.

The Council of American Artist Societies was formed to bring together the practicing artists of the country so that they might be able to run their own business, free from dictation by non-artists, also to provide a clearing house for art ideas, and so that American artists might act as a unit in their dealings with government officials, museum directors, and other outside agencies.

Let it be understood that the Council does not condemn or criticize any serious or sincere form of art but simply insists that representational art be given equal consideration with the others.

All member societies are privileged to send delegates to regular meetings or to designate proxies in New York to represent them. And any member society can offer suggestions as projects that the Council should undertake.

The Function Of The Museum

The function of the museum is to record the achievements of man, not to dictate them.

The art field, dominated by non-artist establishment composed principally of museum directors, is unique in that it permits these directors, by sitting on important juries, to

dictate the kind of things artists may produce.

This set-up is a disgrace and an affront to all self-respecting painters and sculptors.

In a comprehensive joint manifesto on this subject the national associations of artists, most of which have their headquarters in New York stated in part:

"Artists are entitled to juries of their peers, named in advance..."

"We strongly protest the growing tendencies of museum directors and other non-professional associates to direct and control the exhibitions representing American Art..."

"Certainly the artist holds no brief against museum directors, historians or critics, as such, but he raises strong objection when they exclude the opinions of the professional artist in making their judgments..."

"We urge artists not to serve on any competition or exhibition jury or to submit works where the majority of the jurors are not fellow professionals."

Let the production of art be left in the hands of practicing artists alone, and let the special talents of museum directors be devoted to the management of museums.

What Do You Want?
22 x 27 inches 1970

Are Museums Interested In Art?

Among the reasons for existence of art museums one is to aid the art historian in his procurement of informative material; information about the creation of art works in the past and the artists who created them. Most museums are successful in this endeavor.

But paintings and sculpture have only one real purpose— and that is *to be seen*. That is why they are called the visual arts, and the thrill that comes from viewing either should not depend upon its price, its age, the artist's name or anything else. Only its appearance!

So another reason for the museums' existence is to educate, inspire and please the generality of people by allowing them to see the beautiful and artistic creations that have been and are being produced. For this the historical or explanatory features are of secondary importance. It would appear that in this latter category the typical museums are not doing well. To put it bluntly they seem to place greater emphasis on the *names* of artists than on the joy-giving qualities of their work. Examples:

1 Assuming that the non-artist hierarchy in New York should decree that "Adelbert Schmalz is America's greatest painter", every typical museum director in the country would want a specimen of his work, whatever the price.

2 If an unknown artist should paint a marvelously fine canvas and offer it to a typical museum director, the latter would lack the courage to purchase it.

3 Every great artist produces, along with his masterpieces, a certain number of failures. There are artists today who can paint pictures far superior to the second run efforts of the masters. Yet typical museum directors will purchase the former at fabulous prices—using donors' money—but will refuse to exhibit the latter.

4 Painters well known and esteemed by their fellow artists are completely unknown to many museum directors unless the said painters have first received the nod from the New York headquarters.

Museum directors measure the importance of their exhibitions by the number of attendees. Actually, the number of gallery visitors can be controlled or predicted by any good publicist with adequate pecuniary backing.

Suggestion: Let the museum director forget, for a while, names and fantastically high prices. Let him go out into the workaday world of contemporary producing artists and choose artistically fine creations, regardless of the present prominence, or lack of it, of the painters. Let him risk his reputation

as an art authority by exhibiting these works and advertising the show as an outstanding, artistic achievement. He will thus save a great deal of money. If he knows his art the general public will get more enjoyment from the display of fresh talent than from any number of re-runs of the past.

If he doesn't know his art and fails, that means he had no business being a museum director in the first place.

The Establishment

Like every other field of endeavor the art business has its Establishment. As already noted, this inside circle sets the standards and tells the rank and file what to think, like and do. In most endeavors an Establishment is necessary—to keep some semblance of order and apply a guiding hand. It usually does the work that others prefer to shirk. But when the Establishment becomes more important than the enterprise itself, a review of its activities is in order.

The *art* hierarchy or Establishment differs from other Establishments. The medical, legal and architectural establishments, to name only a few, are made up of doctors, lawyers and architects but, astonishingly, the art Establishment consists mostly of non-artists or others who, at best, might be able to offer only a feeble claim to the title of prominent artist. Most of its members appear to be art museum officials whose names could be found in the rosters of the American Association of Museum Directors or the more exclusive Art Museum Directors Association, but to get down to its core I would suggest the names of those who control the American Federation of Arts, the Museum of Modern Art, The Whitney Museum and the periodicals Art News, and Art Forum—all of New York. You may find there is some repetition of names.

There are no card-carrying Establishment members in any field, so no one can prove that a given individual definitely belongs, so we can't name names here, though I am satisfied I could set up a good list, if necessary.

It is said the present Establishment had it beginnings in the Fogg Museum School of Harvard University, and that there a certain line of thought was formulated in the twenties and later disseminated throughout the land. Since that time Fogg has sent out innumerable graduates to work in the museums of the country. I think it is safe to say that the great majority of important American museums are directed by Fogg alumni. It would appear that by osmosis or direct Fogg teaching the party credo has been accepted by college and school art department almost universally and that writers on art have been similarly influenced.

Just what are the inclinations and what is the overall credo of the Establishment, in regard to the selection and display of paintings and sculpture? Let me refer to a few of its tendencies and add my own comments.

An official of a well known museum said: "It is our policy to feature the regular works of deceased artists and the 'innovations' of living artists, and that in my opinion epitomizes the strategy of the entire Establishment." Mark well that word "innovation." I shall have more to say about innovations farther along but let me remind you here this phrase, now standard in the Establishment vocabulary, can mean any eccentricity contrived by an Establishment favorite is worthy of exhibition in museums but that art done in the traditional manner by a living artist is taboo. The specification includes all the weird and shocking things we see—in displays that have brought the feeling about art in general to its present low level. No doubt you can recall a number of examples, but for clarity I'll mention one or two.

In the controversial Kienholz exhibition of a few years ago, the Los Angeles County Museum of Fine Art showed a puppet couple engaged in sex activity, the whole set-up activated by a motor-driven sewing machine. In Central Park, New York, just behind the Metropolitan Museum of Art, an "artist" supervised the digging of a six foot grave before a number of invited witnesses, and then solemnly filled it in. This was acclaimed as a work of art and the happening was duly recorded by the New York press and other periodicals.

Let us all agree that these exhibits are innovations, but how do we know they constitute art, and why should they be featured in art reviews? Does the word "art" have no real meaning? Surely such demonstrations would not have been called art fifty years ago. At that time "art" had a very definite meaning. Is is true, as many now say, that art means whatever you want it to mean? If it does, who changed the meaning and who voted him, or them, authority to do so?

And how can these "authorities" be so blind as to consider there are no innovations within the framework of academic art? A well-informed spectator can stand in the center of an exhibition of realistic pictures by outstanding artists and can name the authors of most without seeing the signatures. This demonstrates clearly that each exhibitor's work must have a character different from all others—in other words his works are innovations, per se.

According to the avant garde interpretations, Da Vinci's epochal demonstrations of the possiblities of chiaroscuro would not be called an innovation, because at the time, naturally, he was a living artist, and he used the same paint, brushes, and application method as his fellow artists. Had he whispered directions into the ear of a mule while the latter painted a

"picture" with his tail, that would have been an innovation and worthy of record by the hierarchy—the hierarchy of today, that is, not the hierarchy of the year 1500. Another characteristic of many Establishment followers is the habit of condemning artists of the past for failing to conform to the standards of the day; standards that the earlier ones never could have foreseen. This is an unfair and dangerous practice.

A few days before this writing I heard a certain museum director, in a prepared lecture, downgrade Da Vinci because his Mona Lisa and The Last Supper were lacking in the sparkle and spontaneity that speaker likes.

As to the hierarchy members' knowledge of art, we must remember that they are erudite persons; they know more about the history of art than practicing artists can hope to know; they know the entire all-important special vocabulary of the art review fraternity, and they know all about art theory. Like the eunuchs in Whistler's anecdote, "they *think* they know how it should be done though they themselves can't do it." However, to really know about art—the guts of art, as of any other business—one has to practice it. What the Establishment knows about the guts of art it gets from the "book."

I have personally known a number of typical art museum directors, typical college art teachers and art critics of the New York Times type and as far as I can see they all talk from the same book. A lecture by any one would follow the same pattern as that by another, even down to the repetitious use of art review phrases. The judgments would all follow the party line.

These people, non-artists or non-professional artists of questionable producing ability for the most part, are in a position to tell the American citizenry what to like, to think and see in the line of art, and for a number of years they have been telling the artists themselves the style they must follow if they want to have their pictures shown in museums or national exhibitions.

"How can anyone dictate what others should like, think or do?" I am asked. Well, it is done indirectly, of course, not by command. Propaganda is simply a matter of stressing one facet of a situation and ignoring or suppressing the others. The Establishment faction can afford the cost of publicity; the unorganized producing artists cannot. Thus, because of conditions or design, the Establishment point of view is dominant in the press, in the museums, and in most situations where the public encounters art. Consider the "docent" set-up as one angle.

Docents are those guides you will find in many or most important art museums who conduct groups through the galleries, explaining the works of art. They themselves are the product of docent classes, where they learn their spiel often by rote. Such lectures are sometimes recorded for anyone to hear

who is willing press a button and adjust the ear phones. These lectures, whether by docents or recorded on tape, are composed, probably in their entirety, by Establishment followers and not by artists. The explanations one hears are often astonishingly misleading. As one listener commented a while ago, "Why don't they leave the visitors alone to enjoy the paintings and get the picture messages directly from the artist himself? After all, the artists themselves have always been the great explainers and there is no reason why their messages should be explained by parrots—or by anyone else."

In any case, with the Establishment in control of communications, as shown by this single example, it is not difficult to convince many of our people of what they should like, think, see or do.

Perhaps it is not wise to over-simplify an involved condition, but it is true that in every situation there usually is a single germ of thought that can explain a lot, and as it is the practice of the day to capsulize into a pat slogan, the whole teachings of a cause. Perhaps, we can; the axiom to say that one way of judging artistic merit, according to a basic Establishment principle, is: "If the average person would like it, it's poor art."

A painting of a beautiful thing—if the painting faithfully reproduces the natural beauty—is now rated as poor art, no matter how masterfully it may have been painted. This is easily demonstrated. Go into any museum exhibition of paintings by living artists and try to find a female form or face beautifully and realistically painted. Virtually no one dares to paint a beautiful woman realistically except a portrait painter, and his work would seldom be accepted in a competitive exhibition. Every female figure must be distorted. This condition applies to other things also, but I use the beautiful woman comparison as being easily understood.

The avant garde enthusaist will reply to this: "There are many kinds of beauty, and a Picasso-like, three-eyed face or distorted figure can be as beautiful as Elizabeth Taylor, if only you want to see it." Of course anyone can persuade himself to see beauty in anything—in a heap of viscera if he is sufficiently persistent—but why should he want to? And if he does succeed why should he feel he must ban all the types of beauty that the man in the street admires? Is there no possibility of allowing all to choose their own type of beauty? After all, that was the demand of the "ism" enthusiasts on their way up. Incidentally, I have noticed that artists who idolize ugly, deformed women, in art, turn to the beautiful bikini type and consider them quite acceptable when arranging a date.

On the whole, there is little independence of thought among typical museum directors. In new acquisitions they don't buy *art*, necessarily—they buy names. Few directors would

have the courage to pay substantial prices for worthy works by an unknown; but let the Establishment bestow approval on a given artist and virtually every typical museum will want an example of his product.

What power does this Establishment have and how is it retained?

The key to its success is publicity, a polite name for propaganda. By this time anyone who follows the news, especially political news, must realize that through publicity one can convince "the people" of anything under the sun. Publicity costs money—lots of money—for rent, assistants to write copy, correspondence and a dozen other necessities. Artists can't afford the price of publicity nor the time required. It takes all their time to paint or sculpt or to teach to make a living. Establishment workers, on the other hand, are virtually all salaried workers: the employees of endowed institutions. When called upon to state their case, say, in distant cities, they are still being paid for their time, whereas an artist must sacrifice production time and pay his own expenses. In ability to polemicize or to sell themselves or their ideas, the art authorities far

Serpentine Sycamores

outdistance practicing artists. They have been educated to talk, not to spend time in manual labor such as painting or modeling in clay.

Thus they have been able to convince the country that they are the logical sources to seek when opinions on art quality are needed. When the government, private organizations or typical museums want to stage a competitive show, do they turn to the national associations of bonafide professional artists for advice or jury nominations? They do not. They turn to the well-advertised non-artist Establishment. An official of the Metropolitan Museum of Art acknowledges to me: "Representational painters are no longer being invited to important national shows." About the only shows that the conservative artists can enter are those staged by their own organizations. When those occasional conservative shows are sent abroad—at the artist's expense, because most of the government sponsored exhibitions are of the stomach-turning variety—foreigners are astonished to learn that superlative conservative work is being produced here.

In the case of a certain prominent museum that follows the Establishment line closely, aroused citizens applied pressure on the Board of Trustees, demanding exhibition of paintings by contemporary realistic painters of national renown. The demand approved, the museum head was ordered to fulfill it. So, flying to New York, he asked a leading light of the Establishment to choose the artists for the show.

In the opinion of many, this New Yorker is the arch-enemy of everything the aroused the citizens want, and probably the least fitted of all authorities for that particular job. Again, the thought of turning to *artists* for guidance apparently never entered the museum director's head.

A few outstanding artists of the conservative school are so popular that the Establishment hasn't the courage to ignore them. These are called the "sacred cows" but certainly no disparagement is intended, for they deserve all the honors they get, but there are plenty of other excellent representational artists who never had a chance.

No, the desire to flout all precedents is not confined to hippies and their successors. It is the order of the day for a horde of intellectuals who should know better.

Incidentally, of all the art "authorities" in the land, I have never heard of one who acquired his position through nominations by practicing artists.

Commercial Galleries

There are two kinds of commercial art galleries: the large, well-established firms with national or international connections and the smaller regional galleries. The latter are always on the lookout for new talent and do help to publicize upcoming artists, while the national institutions *follow* the trends rather than *make* them. They need not take chances and they tend to handle only the work of artists who have "arrived."

In considering the place of the gallery owners in the art set-up we must remember that their business is to *sell*. They may have personal likes and dislikes regarding the art they handle, but presumably, from a commercial viewpoint, they don't care what kind of art is "in" provided business is good. Surely there is no objection to running a business for profit, but it is true that a merchant's requirements develop an attitude different from those of the Establishment. Some regional galleries are run by artists of ability, but this is a rarity.

In regional competitive exhibitions staged by non-artist groups, commercial gallery owners sometimes act as jurors. At least in California, where this book is written, it seems to be the mode to name a gallery owner, a museum man and a college professor as a jury, presumably on the supposition that perfectly fair representation is achieved, but actually it shows the common disregard of the artist who makes possible the whole art endeavor by the non-producing fringe elements of the business.

The general feeling among artists is that gallery owners should concentrate on merchandising, the museum directors on museum directing, and that the judging of art quality, in competitive exhibitions, should be left to artists. Surely neither of the non-producers just mentioned would allow artists to supervise the running of their highly-specialized businesses.

I would classify the non-artist gallery owner as the least acceptable of all jury candidates. Aside from the occasional departure from his real function as mentioned, he probably has little effect upon the overall confused art situation.

CONCERNING JURY PERSONNEL

To all those working in the Arts
To all Art Museums
To all writers on Art

It is the considered opinion of the undersigned organizations that in the selection of works of art for exhibition and in the judging of work for prizes, the majority of the jury of selection and the jury of award should be composed of carefully selected artists of experience and repute.

For all competitions and exhibitions artists are entitled to juries of their peers, named in advance. We note with regret the growing tendency of some museums, foundations, and other organizations to name critics or curators or other laymen to serve on juries, or to name one such non-professional as a sole juror, or to fail to publish names of jurors in invitations to compete or exhibit. No other professions would tolerate such procedure.

It has become common practice to have decisions, judgments and commentaries composed by or under a combination of persons who do not practice any of the arts. We are strongly of the opinion that determination of degrees of excellence and consequence in matters of art must be primarily the judgment of practitioners.

We strongly protest the growing tendency of museum directors and other non-professional associates, to direct and control the exhibitions representing American art in countries outside the United States or in any relation pertaining to the activities of government and art. We contend that when advice on matters pertaining to art is requested by the State Department, or any authorized government agency, that artists in their special professional capacity should be consulted or represented on any advisory committee appointed by the government.

Certainly the artist holds no brief against museum directors, art historians or critics as such, but he raises strong objection when they exclude the opinions of the professional artist in making their judgments.

The undersigned believe that all organizations of artists should condemn this practice and alert thoughtful and responsible citizens to what it implies, and should make public in all proper ways a declaration of principle in order to stimulate a greater resistance to this practice.

We further urge artists: (1) not to serve on any competition or exhibition jury where at least a majority of that jury is not composed of fellow professionals, (2) not to serve where the jury is not named in advance, and (3) not to submit works to competitions or exhibitions where the majority of the jurors are not fellow professionals named in advance. An exception would be made for individuals or corporations holding competitions for works for their own purpose in which all invited competitors are properly recompensed for their competition sketches or models.

We, the undersigned national art organizations, therefore join in issuing this statement to the art world, and to the press.

National Academy of Design
John J. Harbeson, President

Allied Artists of America
Edmond J. Fitzgerald, President

American Artists Professional League
Wheeler Williams, President

American Watercolor Society
Mario Cooper, President

Fine Arts Federation of New York
John Crosby Brown Moore, President

National Sculpture Society
C. Paul Jennewein, President

National Society of Mural Painters
Allyn Cox, President

National Society of Painters in Casein
Ralph Fabri, President

Society of Western Artists
Theodore T. Smart, President

Is Art Worth What It Costs?

In England, and elsewhere, today an expanding school of thought poses these questions:

 1 Of what use are the arts?

 2 Can we profitably discard them?

The questions are worthy of consideration.

The purpose of art is to enrich life and increase the happiness of the human race. Art is not a necessity of life, but is a refinement offered above and beyond the demands of necessity or utility. It is essentially a demonstration of consummate skill or ability produced within accepted rules. It is necessarily difficult of attainment and is achieved only through long study and practice. It can be understood and appreciated only by another who also has labored to learn the principle and characteristics that constitute it as art. For unless both the producer and the observer of the artistic expression are similarly schooled and oriented, no community of thought is established between them—neither party understands the other—the art goes unappreciated, and the entire demonstration represents nothing more than economic loss— loss of time and effort.

Taste is not a natural or inherent quality. It has to be acquired. Our likes and dislikes, even in such fields as music, painting, poetry or dining, are not our own in any important degree. We have been told previously what to like or dislike by interested agencies. This truth has been demonstrated in other writings and need not be elaborated here, although a few examples may be found of interest. Take Flamenco dancing. I like it—in fact I am a great Flamenco fan. I add my "Bravo's" to those of the wildly enthusiastic audience when Antonio, in his "Zapateado," stands for minutes with bent knees and executes with his heels a tattoo so rapid, so lightly delicate, and with such perfect rhythm that he appears motionless, though each of the thousand vibrant heel-taps originates from the hip. What is it that thrills us? Certainly the purr of his heels brings no particular joy. Any drummer could reproduce it with ease, or a muted riveting machine could do it mechanically. His grace—with twisted head and outspread fingers? We may think so—but actually we consider him graceful only because we have been taught to believe that actions such as his constitute grace. No, the thrill comes from our knowledge of the tremendous amount of ability, practice, and study that goes into his dance. In other words, the success of the dance is not due entirely to Antonio's virtuosity, but also to our understanding.

I did not always enjoy Flamenco dancing. Originally it bored me, and I venture the guess that most of the world today would be bored by it. My taste for it was cultivated—by association with things Spanish. Am I happier for my knowledge? I

am persuaded to think so, but it may be that my enjoyment is a negative quality, meaning I am pleased because I would be unable to appreciate such activity were I less enlightened. But am I happier than those who know nothing of the art of Flamenco dancing? I doubt it. I have seen attendees sleeping while it was being excellently portrayed.

It is the same with painting, sculpture, music, poetry, fine writing—any of the accomplishments we have learned to think of as art—as handmaidens of culture. Whatever the form, one group strives mightily to learn the art and a corresponding group studies to enjoy it. Neither would enjoy it without having expended great effort, and conversely either would be as well satisfied if it were non-existent, ignorance being tantamount to bliss. And to satisfy us, the art employed need not necessarily be presently known. Any imaginable activity demanding skill to execute and ability to appreciate would suffice. Walking on the ceiling with suction shoes could be, by general agreement, the supreme example of art expression.

It is all a good deal like collecting stamps, or sea-shells, or minerals. I am told that stamp collections have been sold for more than a million dollars. Yet stamp collections ordinarily have no real value whatever. Nothing can be accomplished (for the world) with cancelled postage stamps. Non-collectors wouldn't give a nickel for them. They have monetary value only because collectors generally have agreed they have value. As another example to emphasize our point: let us remember that the most brilliant play in chess means nothing to one unfamiliar with the game.

It is quite conceivable at some future time we may consider the "checkerboard" school of painting, or "checkerboardism" to be the ultimate in fine art. One with sufficient capital, energy and singleness of purpose, could so convince the world at any time if he so desired. In that school no forms other than squares of varying colors will be used. There will be no atmosphere, perspective, apparent meaning, nothing but squares. Naturally this will offer quite a challenge to the individual artist, for he must still remain an individual and his product must differ from that of all other artists. It will be possible to achieve diversity only by using different combinations of hues or textures, combinations of which can be invented in limitless number. The colors, tints and shades, and the contrasts and the harmonies can become so subtle that only outstanding "authorities" will be competent to detect, appreciate and interpret the differences. Where the man in the street, let us say, will be able to imagine only five or six different greys, the connoisseur will possibly distinguish hundred of shades—warm and cool, pinkish, bluish, greenish, or what you will, and so with all the other colors.

Virtuosity in checkerboardism will undoubtedly require

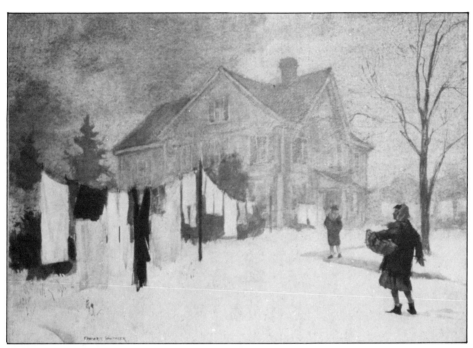

Dirty Weather

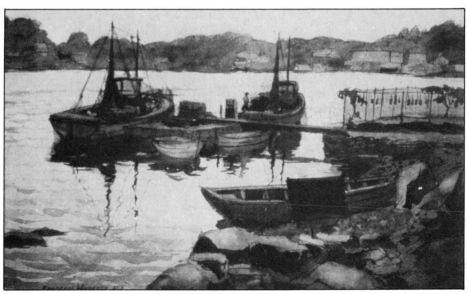

When Day is Done
14 x 22 inches

greater artistic application than ever before, the possible
moves being so restricted. Whole columns in the art periodi-
cals will be devoted to ecstatic exposition of the exquisite com-
position by Saindoux combining levigate squares of deep
violaceous sang-de-boeuf with others of scabrous aureolin—or
that by Steinbeisser, in which the daring artist invites censure
or acclaim by heretically throwing his "horizontal" divisions
into a slight diagonal. While deprecating the "traditional"
abstractionists, schools will teach to art-appreciation enthu-
siasts the fine points of checkerboardism, or checkerism, as it
will eventually be called, so they as well as the reviewers, can
stand in trembling awe before a "picture" of alternating
squares in which the artist has been audacious enough to make
all of identical hue.

 And do not think all this is beyond the realm of possibility,
for the idea is no sillier than others being taught by art schools
and colleges. I have just seen in the New-Yorker a contem-
plated review which reads: "During the Barcelona period he

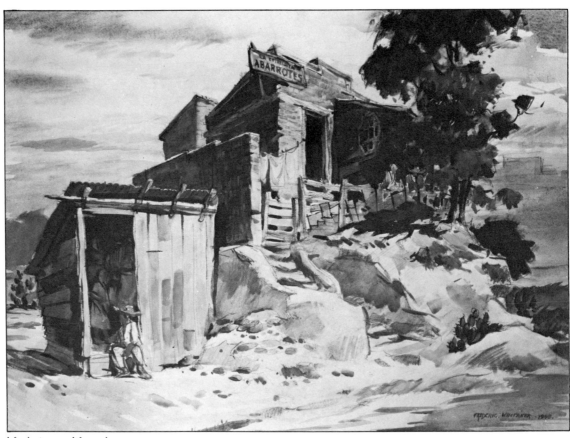

Market on a Mound
22 x 30 inches 1950

became enamored of possibilities inherent in virgin space. With a courage born of the most profound respect for the enigma of the imponderable he produced, at this time, a series of canvases in which there exists solely an expanse of pregnant white."

Let us not forget the world economy and behavior were once thrown into a tizzy by opinions on the relative value of tulip bulbs.

All this means then that one section of the human race spends an enormous amount of time preparing to create purely arbitrary forms—musical, poetic, artistic, sculptural—that we call art, while another section spends a similar amount learning to appreciate them. I say arbitrary, for however different these forms might have been, instead of what they are, even to the very antithesis of our present favorites, we would enjoy and applaud them, provided both the producers and observers had been persuaded by propaganda or by accidental circumstances to beleive they were admirable.

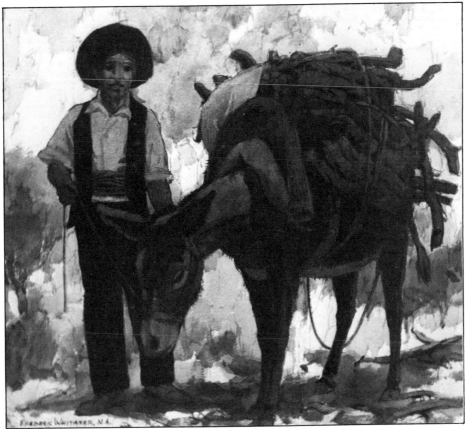

Firewood Salesman
22 x 25 inches

It is easy to demonstrate what we think are our likes and dislikes, our opinions, our thoughts, beliefs and desires are not natural or inherent, but have been, in almost total degree, imposed upon us by others. Knowing this, all should agree then among themselves, the producers and admirers of a certain art are no happier than before they espoused it. True, in the presence of the untutored (in that particular art) they probably do experience a glow of satisfaction—the satisfaction of being superior—though the untutored, except possibly in active comparison with the cognoscenti, undoubtedly enjoy a standard of happiness no lower (and possibly higher) than that of the tutored. So if all remained untutored, all would be equally happy, and the world would have saved a great amount of time and effort. Happiness is a primary aim of human existence. The only thing that presumably would be lost through the abolition of an art would be the joyful sense of superiority of the able—against which could be balanced the eradiction of the occasional feeling of inferiority of the less fortunate.

One might ask himself then, as do the British, whether art is of any real value to the world or at least whether it is worth what it costs. Could we not save ourselves a lot of trouble if we were to put our pride in our pocket, stop trying to amaze our friends with out virtuosity, stop studying to become connoisseurs and thus superior, and just TAKE IT EASY? All this on the assumption something could be done about it—which, of course, it could not!

How do we explain the willingness, or rather anxiety, of the human race to go on expending so much time, effort and money on pursuits that only seemingly contribute to their happiness?

The obvious answer, of course, is that we are running on momentum. Without questions, we have accepted as necessary and correct the customs handed down by our forebears, and we simply go on developing (slightly) the forms of our inheritance. I suppose basically our interest in the arts is a form of snobbery. Probably all culture (omitting the graces, which are useful as a lubricant) is snobbery of a sort, little though we suspect it. It establishes class, and to the possessors it imparts the glow that accompanies a sense of superiority, even though that "superiority" is simply an arbitrary definition. Custom, to most of us, implies correctness or truth, and contrary facts cannot easily change such belief.

Let me assure you, I do not expect the world to discard its art after scanning my few lines here. Nor do I intend, myself, to discontinue painting and exhibiting pictures or to eschew my Spanish friends. In answer to my suggestions about the possible uselessness of art I can hear many say "Ridiculous!—everyone knows that Picasso is wonderful and Wagner is stupendous."

But there are many who do not think Picasso is wonderful, and at one time Wagner's product was not considered music. But once we accept the fact that taste, beauty, preferences and aversions, opinions, and the like are conditions, we are enabled to withstand the contentions of our friends, the claims of politicians, the effusions of the critics and all the rest of the "blah" that goes with "culture" without losing our equanimity.

It may be that the post-atomic age will know nothing of "culture," but if both sexes survive, if they can be warm, dry, and well-fed, I doubt they will be any less happy than we today, who have a thousand forms of supposed art from which to choose!

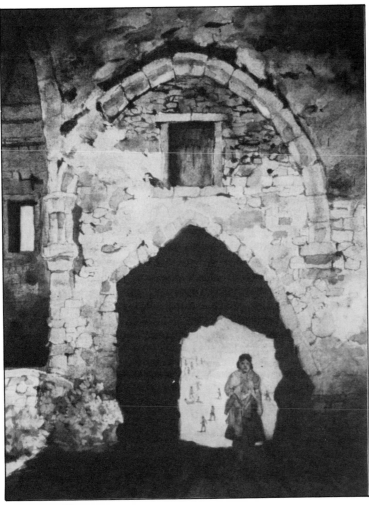

One-Time Chateau
30 x 22 inches

For Whom Should Paintings Be Made?

Today there are two schools of thought on the purpose of painting, and the basic factor that separates them can be stated in a single sentence. In the one school art is created solely to enable the artist to express himself, while in the other it is produced to impress the beholder.

Broadly speaking, those in the first-named group are led to believe that the painting of a picture with the deliberate intention of arousing the admiration of others would be a form of artistic treason, while those of the second group appear to be as anxious to please the beholders of their work as to satisfy themselves.

In the opinion of an increasing group this separating factor is so imposing that two kinds of art produced under the different ideologies should never be exhibited together or judged by the same jury, for they cannot be weighed by the same standards. The two contrasting viewpoints are irreconcilable. This brings up the question, "For whom should paintings be made?" To give a disinterested or objective answer would be difficult. I shall not try. I can only offer my own opinion.

I see nothing sacred about art, and it seems to me that it must be developed with the needs and tastes of the "consumer" or user in mind—the same as groceries, fiction, stage productions, automobile designs and everything else. Lack of consideration for the wishes or opinions of others leads only to irresponsibility, and I see no excuse for artists, alone among all other workers, claiming the right to be irresponsible. Fidelity to those who furnish us with the means of existence (for those who provide nothing the world can profitably use must necessarily live off the proceeds of others) does not mean the artist becomes a hack, but it does mean his work must be used for a purpose: a purpose more important than tickling his own ego.

Any product of human effort should be able to provide a sensible answer to the question, "What is it good for?", and that means, "Of what use is it to the world?". If it has no value to society or no promise of later value, the time spent in contriving it has been wasted. In brief, all art must convey something to the beholder, something beyond "Whatever he wants to make of it!" That the artist "expresses" himself is not enough. Art that *expresses* but does not *convey* is no art at all. It is of no more importance than the chirping of a cricket or the baying of a hound at full moon. Messages are for the receiver —always! What rational being sends messages to himself? Or if he does, by what right does he expect others (except psychoanalysts) to spend time in considering them. Even if messages

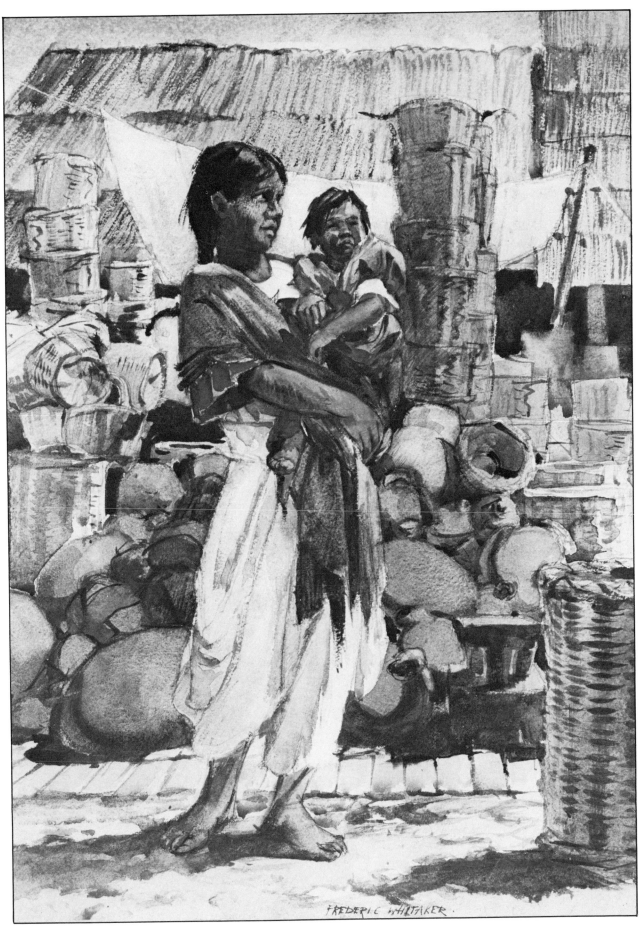

FREDERIC WHITAKER.

103

The Sisters
30 x 22 inches

are designed for others they have no value unless their content is made interesting to others.

Let us suppose non-artists, such as automobile manufacturers or other industrialists, were to adopt "self-expression" as their only aim, designing and keeping their product for themselves alone. What would happen? They would soon hear from Big Brother in Washington—and the artists themselves would not be far behind in crying "Unfair—Unfair!"

The intent behind this advocacy of "self-expression" is an admirable one. And the thought is to bring out from each individual his own personal viewpoint which, naturally, should be different from everyone else, but it is quite apparent somewhere along the line the theory or intention has gone awry. If such a thing is possible, there is less originality displayed in the product of the "self-expression" schools than in the product of academic teaching. View the overall work of any one of our "progressive" art institutions and you must agree it could easily pass for a comparable exhibit of any other such institution. The kinds of work turned out throughout the country can easily be classified under, say, a half-dozen headings. Or, to put it otherwise, there is nothing so regimented as the work of those who are fighting regimentation. This fact should not be ignored. If real individualism is the aim, how can any teacher be of service? How can art be taught at all?

The artist, like everyone else, owes something to the world—something that world itself wants. The real artists of the

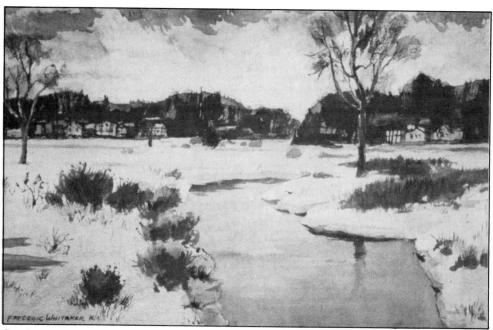

Sundown
14 x 22 inches

past have always been *givers*. They have been honored for their tangible contributions, not for their self-directed artistic mutterings. The world expects from the artist beauty, inspiration, edification, or leadership. Who cares what some introspective occultist thinks as he communes with himself?

If we have nothing to say, let us say just that and make way for the more articulate ones. Our fellows are not interested in mumbo-jumbo, artistic or otherwise.

Art And The Public

There are those who like to imply that art—painting and sculpture—is a hallowed subject to be discussed intelligently only by those especially educated. This means the general public should refrain from judging and should look up to its betters for opinions.

This is a modern conception, for in all earlier ages art was contrived to convey messages directly. The artist was the great explainer. With pictures and sculpture he illustrated important truths to help the humble and erudite alike. So it seems odd, as under today's curious outlook, that anyone might suggest the artist needs an interpreter.

A professional story-teller can describe an incident in a concise and entertaining or edifying manner, where one less skilled would be dull. Both subject matter and style of presentation are required for a successful story. A brilliant discourse on a trivial thought can have no lasting value. The superior manner of telling, plus the choice of a worthwhile subject, constitutes art. And so it is with picture making.

The non-artist is likely to judge art too much upon the score of subject matter or theme, but he should remember that subjects other than the pretty ones can be important also. Art need not always be pleasant, but it should say *something* and say it in an understandable manner.

In contrast to my opening premise, many will contend the artistic taste of Mr. John Citizen functions on a higher plane than does that of the professional interpreter. Well, the public may be misled by tawdry subjects at times, but nearly always it will admire really fine paintings, without knowing why. In any case, no form of art can have enduring success unless it appeals to the generality of people. For some time certain followers of peculiar "isms" have dominated the stage, but they haven't satisfied the people. That accounts for the confusion in art today.

It will be a great day when the non-artist sheds his awe of the museum and asserts his God-given right to express himself on what he sees on its walls.

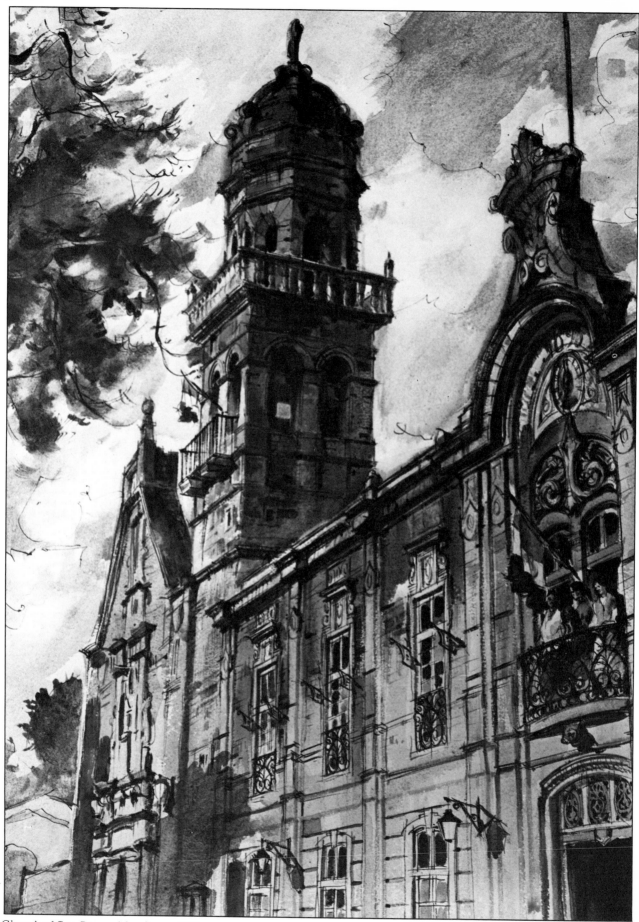

106

Church of San Diego, Morelia . 1946

The Lure Of The Unusual

News-gathering agencies are more concerned with human aberrations than with human rectitude. For every article about a man's virtue we read a hundred reports of his misdeeds. Those who live in New York want to travel in South America and South Americans want to visit New York because each is interested in the unusual. A thousand comparable examples could be quoted.

This concern with the unusual is a universal human trait, and it explains many otherwise unaccountable activities. In the matter of art, for instance, we can understand how those whose business is not to produce art but to talk about it have always an eye open for the unusual—and the more unusual, the better for their purpose—their business being to talk, some of them like empty-headed gossips draped over backyard fences. Even the so-called artistic product of patently diseased minds can send them into tizzies of excitement and rapturous analyses of what the unfortunate psychotics are trying to "express."

This preoccupation with the unusual explains the emphasis on unconventional art today: for taste and interest in art is created, not by artists, but by those professional talkers on art and publications that encourage them. Anyone, adopted by this combination, can quickly be made "famous", regardless of his real ability.

Left to their own devices the taste of the public would run naturally to representational art, which may or may not be a compliment to that branch of aesthetic production. But at least their opinions would be their own rather than those imposed by brain-washers.

I would be the last to object to the pursuit and investigation of the unusual, for only so doing can we attain new goals—and, after all, anyone who presumes to argue with Mother Nature about the inclinations she has bestowed upon us is a dunce himself. But let us not lose our perspective. The unusual carried too far becomes an aberration. Aberrations are interesting to contemplate and discuss, but real progress comes from orderly procedure. I still favor giving medals and erecting monuments to the virtuous, the honest seekers after unsensational truths, and to those who obey their own consciences rather than the promptings of lay sensation-mongers. Truly, a real artist should know more about the art business than does a mere onlooker.

Maybe we ought to let the artists themselves say what they are driving at, with their works and verbal comments, and ask the self-appointed explainers to shut up for awhile.

Trying Too Hard To Be Different

Overheard in a club: "You try too hard to be funny. The essence of a joke is surprise. The ending has to be *different.* But your material is *too* different. Your audience can't or won't follow the reasoning through to the punch."

"He tries too hard to be funny" is also applied now to other kinds of story telling—through pictures, for instance. Of course all progress comes from new ideas and different methods, but today the art world seems to be obsessed with the need for change that it doesn't ask whether the change is beneficial or detrimental. It happily hails *any* suggestion of difference, regardless of how ridiculous the departure may be. The present cult calls for change merely for sake of change, as in women's fashions.

It hardly seems necessary to quote corroborative examples, so many are visible to all. Crushed tomato cans, glued to a ground and passed off as picture, are not outdated, so voluminous has been the flood of new and insanely different offerings. At a recent exhibition a man's trousered leg, apparently growing out of the gallery wall, with the knee bent to let the shod foot rest flatly on the floor, was shown as a serious piece of "sculpture". Perhaps the "farthest out" example of difference to date was that of the "artist" in England whose entry was a glass case in which he himself posed in the near-nude. This, or he, was classified as sculpture. A leading art college sends me expensively prepared monthly bulletins "embellished" exclusively with eye-straining "op art" compositions that could have been made by any non-artist.

Real art ought to transcend gimmickry and childish demands for attention, for if this is art we had better abandon it altogether and put its perpetrators to work in some useful field.

Of those who follow the line of exhibitionism described the most charitable comment one could offer would be, simply: "They're trying too hard to be different."

Twenty-One Channel Art

I have just listened to a new stereo record claimed as a great step forward in sound reproduction. It suddenly reminded me of what is wrong with the art business and, in fact, what is wrong with a large segment of American life and thought.

The record reproduces orchestral music picked up by twenty-one microphones in "The most exciting listening available on records today: the ultimate in separation; the cleanest definition of instruments; the widest range of realism."

And a remarkable recording it is! At times each instrument can be picked out by ear quite separately from the others; and the arranger has cleverly planned the performance so that the lead shifts repeatedly from one section to another, so that the trumpets may dominate the performance for a spell, then the strings, the drums, and the others in succession. In fact, this is such a perfect example of recording, and of emphasis on individual details that one, in listening, hardly recognizes the air being played.

And that demonstrates what is wrong with some American thinking today—especially in the field of art. We are all so anxious to demonstrate something new in the way we paint, we forget the purpose of painting is to reward the viewer, and the content of the message is of much greater importance than the way it has been composed.

I see many artists painting in curlicues, zig-zags, loops, and blobs, not because that is the way they instinctively feel, but because they must please the taste-makers; they must be different if they are to gain their attention. Knowing many of these artists personally and intimately, I would say the great majority who paint in the manner described do so because they feel they must conform in order to exist.

Looking back over art history, at the great contributors to the art of painting, to the founders of the new-idea schools, I am satisfied none ever said to himself, "Now I'm going to be original and concoct a new style of painting." No, their advances came about gradually, step by step. From accidental passages that pleased them they took the essence and developed it; thus, after many improvements, they found they had something "new."

Originality comes from the inside, not from deliberately planned eccentricity. Demented people who paint in blobs and daubs are really original, for that is all that comes out of them: but when mature, intelligent artists do the same only to gain attention, that product is not original. If one has something worthwhile inside and has the ability to express himself in words, paint, or music, it will eventually come out. But it won't come out if it isn't there.

What's Wrong With The Art Business?

The great majority of our citizens, artists and laymen alike, hold to the belief there is something hallowed about gallery art. They feel art must be discussed only on an elevated plane and in reverent tones, and that the man in the street is incapable of understanding or appreciating it without first having been conditioned to it by the cognoscenti.

This of course is just so much rubbish, for in all great art-producing periods heretofore, painting and sculpture have held the understanding attention of the humble and erudite alike. But let us inquire into the causes for this attitude. We must go back nearly a hundred years for its real beginning, when the French Impressionists and Post Impressionists launched the idea that an artist's method of expression was more important than the theme expressed. The immensity of this revolutionary thought has not yet been fully grasped. In the world's transactions up to that time all production was effected to please the recipient, observer, customer, or the world at large. Under the new system the producer produced to please himself, and the opinions of others were of secondary consideration.

From that position in which he was declared responsible to no one, the collective artist in less than a century has become completely irresponsible—and the end is not yet. Like a religion without a governing head that breaks up into innumerable sects, art has brought forth dozens of *isms* since the Impressionists established themselves. In fact, to many, Modern Art has become a sort of religion, with dogma, proscriptions and indulgences and an Elysium and Hades for those who accept or refuse to accept the credo. The credo must be taken on faith, which comes to the followers by instruction rather than through spontaneous or independent thought. The many sects may differ among themselves but they always close ranks to fight the common enemy, the unbeliever who rejects the *ism* concept completely. The controversial points have been so many and the trifling differences in doctrine have brought out so many factions, that a whole horde of explainers has arisen. The great majority of these explainer/indoctrinators are not themselves artists. Explanation or interpretation is now a distinct profession and undoubtedly is more important to the continuance of our present-day kind of art than is the art itself. Explainers can justify anything. Without their attendant wordy descriptions most *isms* would collapse overnight.

Actually, the explainers, the high priests and prophets of the art cult, are just about in full control of the art business, with power, which they regularly exercise, to exclude from

most of the important exhibitions those who refuse to conform. But it is quite evident that they have not yet won the general public to their side. Most of our citizens refuse to be indoctrinated in the Modern Art movement.

The art fraternity and the general public are now so far apart that one might say the contact has been lost. That is what is wrong with the art business. Something should be done to heal the breach. Two steps are necessary.

First, the laymen should be reminded that in art matters his opinion and approval are indeed of the utmost importance. And secondly, the professional artist must be persuaded to abandon his ivory tower and offer his painted messages in terms the average individual can understand.

Art's aura of pseudo sanctity that so discourages the laymen should be removed.

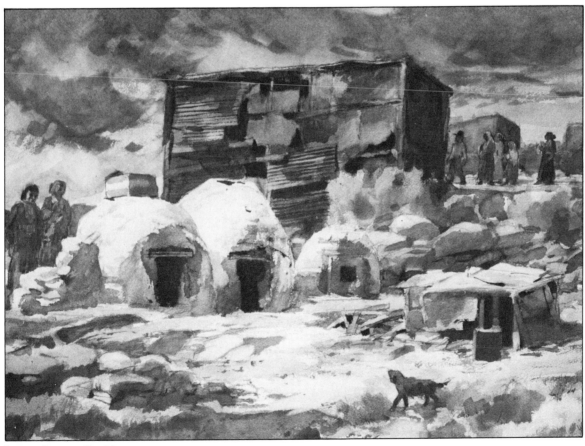

Ovens, Laguna Pueblo
22 x 30 inches 1970

Why Does Art Have To Be Explained?

From the beginning of human existence until a few years ago the artist himself was the great explainer. The great mass of people have always agreed "a picture tells more than a thousand words." But now, it seems, the explainer himself—the artist—must have an interpreter. Are we then unreasonable in asking: "Of what use is a painting if it must be spelled out?" And if all this translation is necessary, why not save the trouble of painting pictures altogether and simply substitute verbal descriptions of what they ought to mean?

Having published a novel, what would an author think if some "interpreter" would presume to explain what that author was trying to say? I suspect the interpreter would be clobbered. Yet that practice is routine in the art business.

Of course, one answer to our conundrum is that certain artists don't say anything in their paintings. Frequently we are reminded that such pictures mean what you want to make of them: that each observer is free to extract a different, personal meaning. Let's revert to our parallel novelist and assume he were to publish an incoherent assemblage of words, stating you may seek in them whatever meaning pleases you. How many books would he sell?

To the credit of the good reviewer, we must agree he can assist the lesser informed to perceive the beauty of the way of telling and the skill exercised in the work. But to presume to tell the layman what the artist or writer *means* is something else again. What is the artist's or writer's business except to say what he means? If he can't do that he cannot reasonably expect others to spend time or money to promote him—and in the case of the unintelligible author certainly no one would publish his work. It is only in the visual arts that one can produce meaninglessly and expect to be taken seriously.

Every other cultural endeavor must satisfy the public or expire. Operas, concerts , and literature are expensive to produce, and no one will supply the money without a fair chance of retrieving it. The producer must please his customers. But to enter the fine art business one needs only a canvas and a few traps. This constitutes a direct invitation to irresponsibility.

There is little real contact between the art world as a whole and the public. The "authorities" have tried to bring about by words that rapport which the paintings themselves have failed to achieve, but the meaningless jargon of certain viewers have doubly compounded the mess.

Would it be unreasonable to suggest that the artist himself be permitted to state his message, if he really has anything to say, through his work. Let him be judged directly by that work rather than the statements of a lot of uninvited "explainers", who (for the most part) really know little about the core of the artists business?

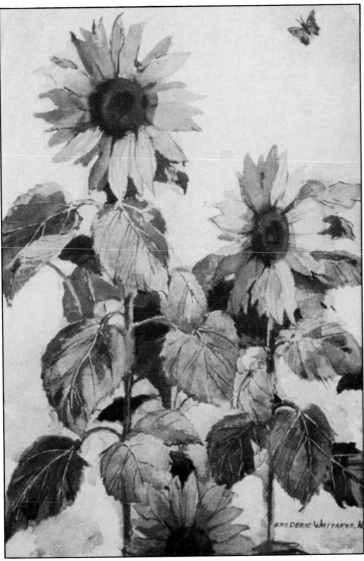

Sunflowers
14 x 20 inches

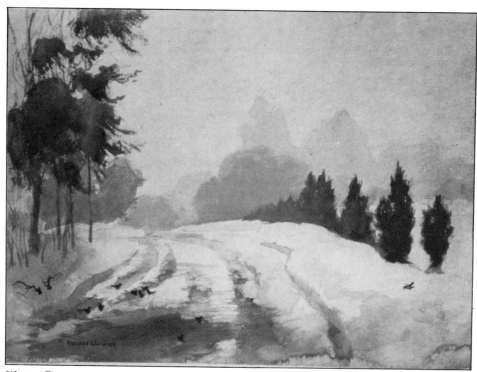

Winter Fog
20 x 30 inches

Country Market
20 x 30 inches

Artistic Gobbledygook

It is possible to write perfectly correct English that virtually no English-speaking person can understand without an interpreter.

The Pentagon has proved that, and if you want further evidence, just try to decipher a message from *Who's Who* when it asks for biographical details.

Every trade has its argot whose use can save a lot of conversational time for its members, but when a specialist speaks to the generality of people, as through newspapers and magazines, common courtesy and common sense should persuade him to use language understandable to the average educated adult.

The art world is particularly plagued with gobbledygook. With many of today's astonishing art offerings the reviewer really has little substance about which he can write, so he fills the space with a wordy mish-mash. How do you like the following, from a leading magazine? "X's new collages at Rose Fried are fields prepared to receive the 'inevitable' touches of orange near greyed brown near browned grey near white near cold black. Inevitable. Edges of paper, some still with color, some softer, found bits, are torn and sliced with that thoughtless omniscience that joins a mandarin to a carpenter and this Castillian to Tenth Street."

In a controversy a sharp debater who knows he has no case often falls back on the old trick of confusing the issue, of muddying the waters, confident that if he can hold on long enough no one will be able to remember what is right or wrong, thus giving him at least a fifty-fifty chance of winning, and if his listeners are gullible enough he is almost sure to win. This fact undoubtedly accounts for a certain amount of art gobbledygook.

Then it seems that throughout history critics have wanted to inject *themselves* into the discussion, and it is quite evident that of the present-day crop many are anxious to direct attention to themselves, through verbal contortions, as to the work they are supposed to be reviewing.

My advice to you regarding art-reviewer's double-talk is that you refrain from trying to understand it. It doesn't mean anything!

Let's Take Art Out Of The Clouds

Correspondents and artist friends charge me with "leniency" towards members of the workaday world in considering their views on art sympathetically. They resent my sharing with the tradesman's questioning view of the halo about ART that its practitioners like to think is there.

I realize that the generally accepted "official" artists' attitude toward the men of industry is one of indulgent disdain. The money-grabbing businessman is too "materialistic" even to sense the artist's astral mission. I also remember that to the Hellenic Greeks, "barbarian" meant anyone not fortunate enough to be a Greek.

Several years ago, so that I might paint as I pleased, I willingly gave up a business that paid me many times what a good easel artist might expect to earn, knowing at the time that the men of commerce reciprocally looked upon the collective artist as a soft-headed dreamer. So it can't be said my opinions are entirely materialistic. I think my two-sided experience has given me a judicial advantage neither the artist nor the businessman ordinarily enjoys, and it is evident to me that both parties to this contemporary variance are largely right and partly wrong in their views of each other.

I should like to see art come down to earth, divest itself of its imagined sanctity, and realize that to be of any value to the world it must work in harmony with the great majority of people who are not artists and deliver a product that they can understand and want.

The artist, in his introspection, seems to forget his fraternity comprises only a small part of the world population. We can't disparage the great cultural lift art has given to humanity, but we must remember the non-artist majority are not all barbarians. They also have contributed mightily to civilization. In fact, most of the progress about which Americans boast has been materialistic more than emotional; and art, after all, is largely a matter of emotion.

The fault lies not so much with the artist himself as with the current non-artist, art-thought-control group which, in its rapture, has made of art a cult which only the Brahmin can understand. The art tangent now seemingly endorsed by the said control group certainly takes "art" steadily away from the circle of public comprehension. It can result only in complete repudiation of art by the generality of people. The direction must be reversed or the art field split into its two present component parts: understandable figurative art for the majority and the now-reigning esoteric brand for the self-appointed Brahmins.

Remembering again my ancient history I recall the practi-

cal Romans were "barbarians", according to the Greeks, but they demonstrated an ability to take over the Greek artist, body and soul, and upon his imaginative ability to fabricate an architectural and cultural structure whose influence has never been equaled.

Perhaps we artists had better establish discipline within our own ranks before we find ourselves, like the effete peoples of history, forced as bondsmen into practical production by the "barbarians" we now despise.

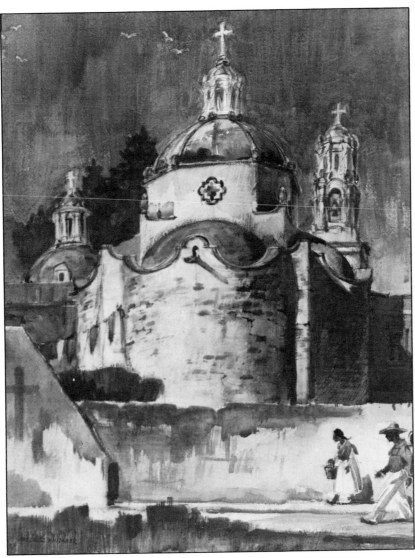

Toluca Church

Back To Illustration

Reviewing the great circulating exhibition of paintings and sculpture by Frederic Remington and Charles Russell, famous artists of the West, certain reviewers of the standard type have referred to the paintings as "illustrations." That they are! But in the eyes of the tastemakers who dictate art thought in this country, "illustration" is a dirty word. In their meaning it refers not only to any art used for commercial purposes, but to any picture designed to convey a specific message or to please the beholder by its subject matter. On the other hand, non-illustrative art, the kind that pleases the authorities, theoretically must ignore subject matter and must depend for its appeal on its manner of presentation—and the more different or unconventional the presentation, the better they like it. A rough rule for separating the two, as might be used by many today, would run about as follows: "Unless the technique or manner of presentation is more arresting than the theme, scene or subject, the picture is an illustration."

Actually the viewing of the Remington-Russell show should offer a thrilling experience, artistic and emotional, to any informed or cultured person. Contrasted with the official attitude that decries most realistic art, this points up the fact that what we need is more illustration.

Until the beginning of the parade of the "isms" about a hundred years ago, Impressionism, Futurism, Dadaism and the others—virtually all paintings were illustrations in that they told a story or described an event in a manner that one could understand. The development of the camera, burgeoning at about that time, seems to have given the artists a feeling of inferiority on the score of realistic representation. They decided to concentrate on their *style* of painting rather than on choice of subject and leave the story-telling, or message conveyance, to the camera.

Actually, this surrender was unnecessary, for a camera cannot *compose* a picture. Some clever photographers produce some remarkable photographs but in general the camera can capture only that which it actually sees. Unlike the photographer, an artist can paint ideas and he can arrange and rearrange subject components as he pleases. The composition or plan of the picture is its most important part so as long as imagination in picture content is called for the artist will always be needed.

In years gone by, the viewing of good pictures was an enjoyable experience. One could stand before certain paintings for long periods and remain thrilled by their sheer beauty. Such an experience was an emotional one that could be enjoyed by artists and laymen alike, and the laymen could be informed or uninformed in artistic matters. That possibility

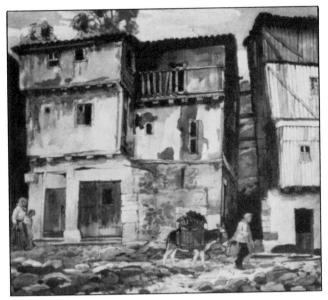

Tumbledown City

Izaak Walton Et Ux
22 x 30 inches

hardly prevails relative, at least, to what is called avant garde painting. The current consideration of art value is an intellectual rather than emotional one. Avant garde art can be put over only by words and can be discussed only by those conditioned to it by indoctrination. Without the words it has never been accepted by anyone.

The real function of avant garde art is that of a status symbol. It allows the homeowner to say: "Look, I'm with it." The well-to-do feel that they must own genuine, contemporary paintings to advertise their cultural standards. Satisfaction comes from ownership rather than from contemplation of the works. I know many such collectors, and I find invariably their pertinent comments allude to values or the fame of the artists and not to the joy-giving qualities of the works. But the paintings will not guarantee cultural standing long, for the history of the "isms" shows that each lasts about ten or fifteen years and is then forced into the shadows by another founded upon a new twist of credo like a new-spawned religious cult.

Since renouncing *illustration* and relying on the method of presentation for novelty in painting, the art field has been in a dither, hopping from one "ism" to another. The art fraternity has found no permanent place to light.

The art of painting must eventually revert to its former purpose, that of edifying or pleasing the viewers. That is, bluntly stated, illustration, for without illustration pictures serve little artistic purpose.

The Artists Themselves

Aside from their chosen activity, picture making or sculpture, artists as a class probably have the same intelligence rating as others and are as susceptible to brain washing as anyone else. In fact, the percentage of people in any line who can do their own thinking and restrict outside propaganda is very small, so it is not surprising that a large number of artists have fallen for the "innovation" line. But in their case there is at least one extenuating circumstance, namely that many are compelled, or feel they are compelled, by economic conditions to incorporate outlandish features in their product. Many individual artists will sincerely deny this, but nevertheless the fact remains. Whatever our thoughts, we all think they are our own, arrived at independently. But every school of thought must necessarily originate with a single person or agency, and when we find a large number of individuals thinking identically we know their belief has been imposed upon them—by education, persuasion or brain washing.

I know personally a great many American artists, and I

Fuschias
22 x 16 inches

think I know how the average artist thinks and feels. I *know* many have joined the "innovation" movement because that is where the present day profits and plaudits lie. A former president of a well-known art association writes that it is going completely "abstract." He continues: "I now submit abstractions myself, along with other conservatives you know, although we have no enthusiasm for such work."

Eventually, of course, one naturally becomes satisfied that his "innovations" are his own, even though anyone can see that they all fall easily into a few classifications. It just isn't possible for even the brightest minds to provide in the short time alloted as many and as varied approaches to art as the non-artist authorities expect.

It is easy to run with the crowd or to fraternize with the conquerors, but it takes courage to stand by principle, to resist being hurried along by untried and unpromising theories and to maintain that change alone, just for the sake of change, means nothing except eventual chaos.

Change is always expensive and is acceptable only when it connotes improvement or promise of improvement.

That the avant garde artists on the whole seem to favor domination of the art business by the non-artist authorities is understandable. Why shouldn't they? An indication of their servility is the fact that the following attitude is repeatedly expressed by the artists themselves: "I don't feel that artists are qualified to judge their own work. Non-artists have a clearer perspective of the whole business." I wonder if doctors or other professional experts would be gullible enough to subscribe to similar appraisements of their abilities—and I also wonder if these avant garde artists themselves would feel the same if, suddenly, they were deprived of the plaudits now received.

But the astonishing feature of this whole situation is that despite the bitter prejudice and discrimination against realistic paintings and sculpture by Establishment followers an enormous amount of fine representational work is being produced. Perhaps the average American, and certainly foreigners, see little of this work, but if you will visit the exhibitions of the great national artist societies you will realize that fine contemporary work is available in quantity, Many sturdy ones refuse to knuckle under to the powerful psychological pressure.

And this applies not only to the older artists but to a great number of young ones as well. Recently interviewing a young star who paints large oils in the *trompe l'oeil* manner, I asked how it came about that he painted thus, having studied for four years solely in a markedly radical art institution. He replied: "I was one of several in the class who paint realistically. We couldn't stand the rubbish handed to us, but as they don't *teach* anything in these schools anyway—simply subjecting us to a lot of *suggestions*—we ignored the whole thing and painted as we

liked. In any case, students learn mostly from each other." This brilliant painter is representative of a whole class of young realistic painters. Rebellion, of course, always brings about counter-rebellion.

Seated Nude
14 x 20 inches

Realistic or representational art can be enjoyed by anyone, regardless of his knowledge or ignorance of art matters, but virtually no one has ever become enthusiastic about avant garde art until after having been appropriately indoctrinated. In representational art one finds mood, atmosphere, distance, three-dimensionalism and all the variety of technique, inspiration and edifying message that any sober mind can demand. No cheap exhibitionism is required to emphasize these points but certainly consummate skill, experience, sensitivity, and balanced judgment are needed. By no exercise of the imagination can this be said of non-representational work.

For the following I shall be accused of heresy, but the best kind of art being produced in this country today in my opinion, is to be found in the division of commercial illustration—through Establishment members, cramped by their "infallible" credo, will continue insisting that "The lowest form of art is illustration."

Illustration is one of the few courses being *taught* in art schools. In other departments, as already indicated, mild suggestion is offered as instruction lest the sacred emissions from the students' psyches be contaminated by the thoughts of others. However, it may be difficult for the more practical-minded to see how anyone can draw original thoughts on anything from an inherently blank mind or until he has learned about the earlier facts of the subject.

In illustration classes students are forced to learn the fundamentals of art production that have always been considered vital in any form of painting: drawing, technique, composition and the like. Many students today, wanting to master these fundamentals, enroll in the illustration courses without thought of ever becoming anything but "fine art" painters. As for inspired conception or idealistic "creation" that fascinates so many authorities, there is nothing to indicate that illustrators are any less endowed with the essentials than the dreamy-eyed ones who have drifted into their titles of "artist."

It is revealing just to visualize these two types of artists, as individuals, and to note how much more alive and inspired are the illustrators.

Illustration is the one branch of art for which the United States can be proud, and I venture the guess that when reason returns to the world and our present era is assessed, this fact will be acknowledged.

Illustrators, by their very name, paint for the edification, approbation and delectation of *others,* in contrast to their opposite numbers whose goal is simply "*self*-expression." These two purposes themselves should indicate their relative values.

After all, almost all of the world's great art, produced over the centuries, is illustration.

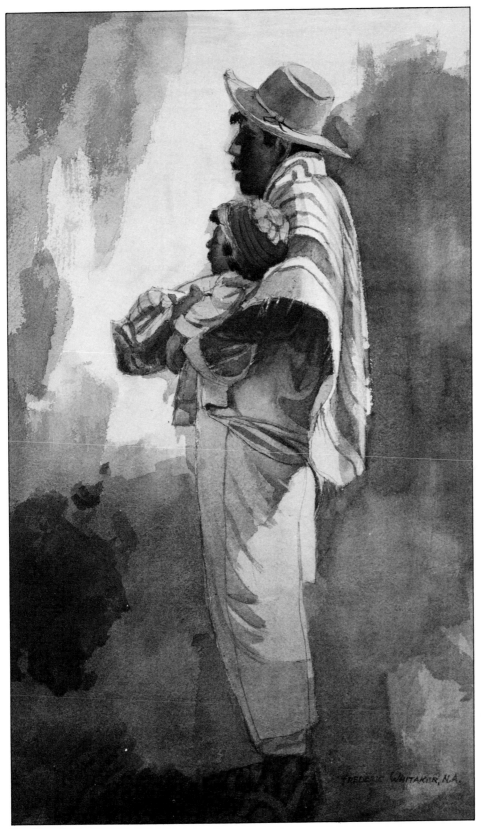

The First Born
30 x 18 inches

The Remedy

The remedy for the crazy situation in the art business is essentially simple. Take the non-artist art politicans who are the Establishment off the backs of the practicing professional artists. Return control of art production to the artists themselves and let the museum directors return to their legitimate business of running art museums. The purpose of a museum is to record the achievements of man—not to direct them. Can you imagine airplane manufacturers accepting dictation on the design of their product by the Smithsonian Institution or the medical or legal fraternity permitting domination of their professions by non-practitioners?

In implementing the corrective program let us insure that government and any other publicly supported institutions such as art museums, libraries and the like turn to real artists or to bona fide artist societies when they need assistance and advice on art matters. Let us insure that juries of acceptance and awards in open competitive art exhibitions be manned only by real artists or at least by a majority of real artists. Let us have separate juries to judge the works of traditional and avant garde artists or, better still, hold entirely separate exhibitions for the two classes. And let us insist that publicly supported museums allot as much time and space to the work of contemporary traditional artists as to the work of the non-traditionalists and suggest privately supported institutions such as newspapers and magazines adopt a correspondingly fair procedure.

If these measures are carried out, the art business would return to a sensible level in a very short time.

How do we break the spell and force the change? This will not come about simply by request. Bureaucrats, whether of the government or corporate variety, don't relinquish power willingly. Under present conditions about the only way that change can be effected is through the public, which is strongly on the side of understandable art. But the average citizen will not speak out for fear of being branded a reactionary or a dolt. Actually, the public, despite its propensity to judge art largely on subject alone, has better innate taste than most members of the Establishment who get their opinions from the book and who have lost their sense of balance from too-close inbreeding.

Sycamores
22 x 24½ inches

Park in Uzes
22 x 27½ inches

Art Alone Endures

The great Foundations, created by American industrialists to sponsor cultural development, seem to lend sympathetic ears to pleas for support of educational and sociological exploration across the globe, to mention a few causes, but for American art and American artists they appear to have little sympathy. Those few foundations that do include art in their interests—the Guggenheim, the Rockefeller, etc., presumably are interested only in that kind of art which is called, for want of a better name: "Modern".

Gifts and bequests have been made for great museums and for purchase of the works of artists now dead, but the benefactors who demonstrate their interest in living American artists, through the encouragement of Academies, through the purchase of artists' work, seemingly could be counted on the toes of a one-toed sloth.

As Gautier said, "All passes—art alone endures." Perhaps America should interest itself in the direction along which American art shall endure, by re-discovering our creative painters and sculptors and by grasping the wealth they offer us. Is one being too optimistic to envision a day when at least the outstanding American artists asked, "What do you do for a living?", can truthfully answer, "I live by creating new art forms and methods and by contribution to the artistic glory of the U.S.A."

Color Portfolio

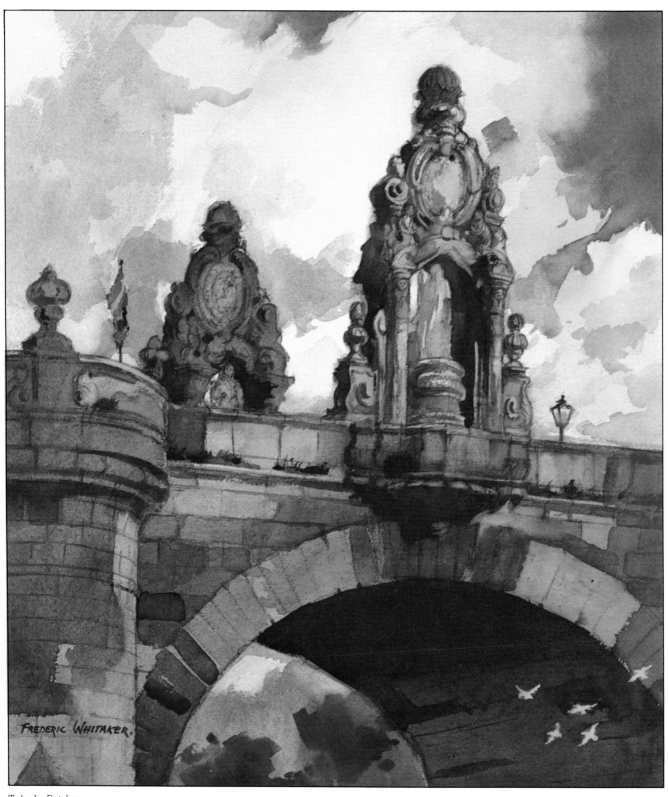

Toledo Bridge
25 x 22 inches 1965

130

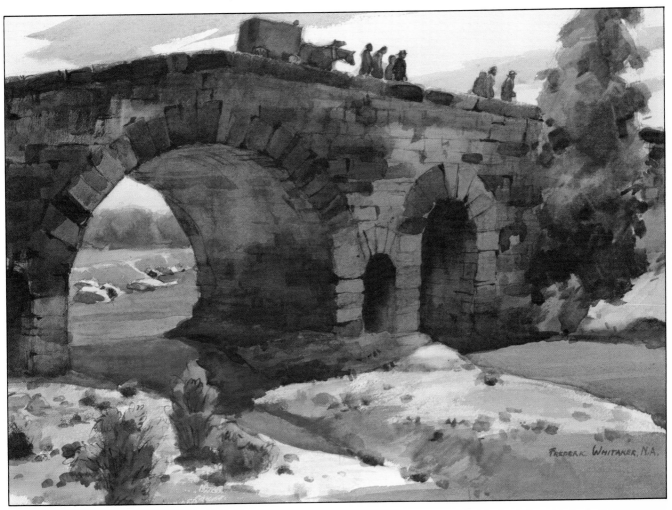

Murky River
21 x 29 inches 1968

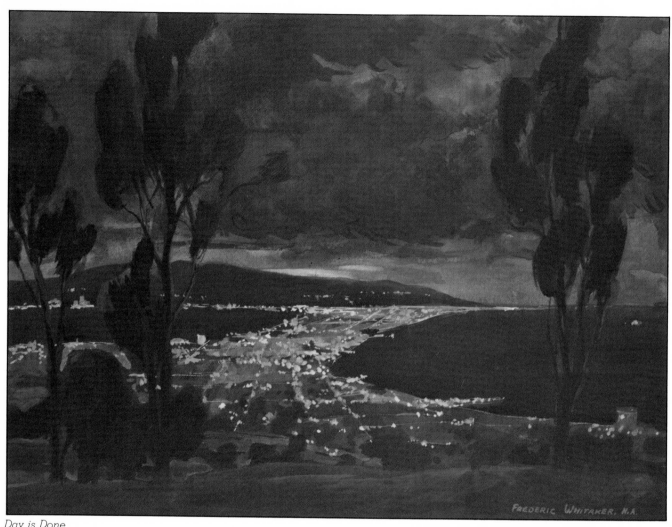

Day is Done
22 x 30 inches 1971

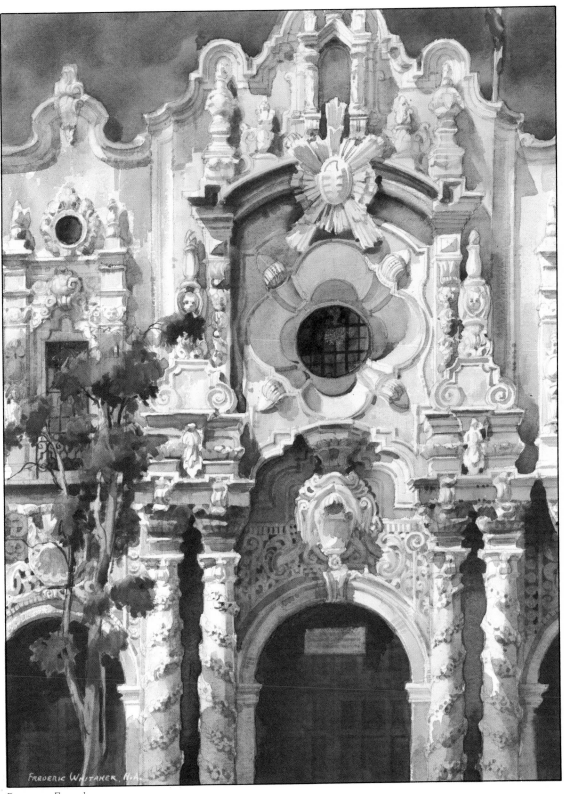

Baroque Facade
28 x 22 inches

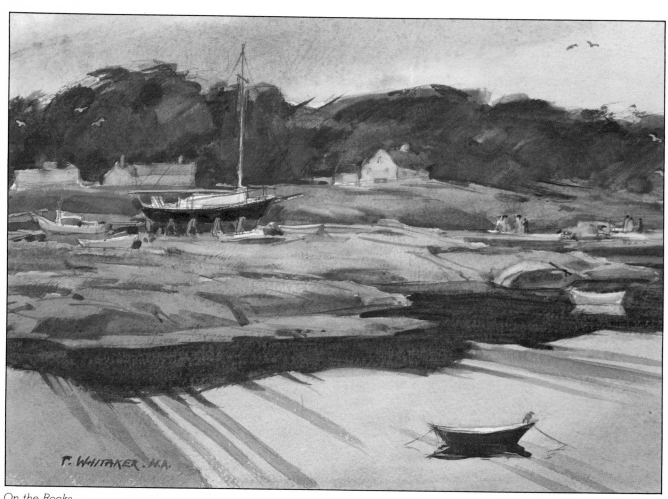

On the Rocks
14 x 20 inches 1965

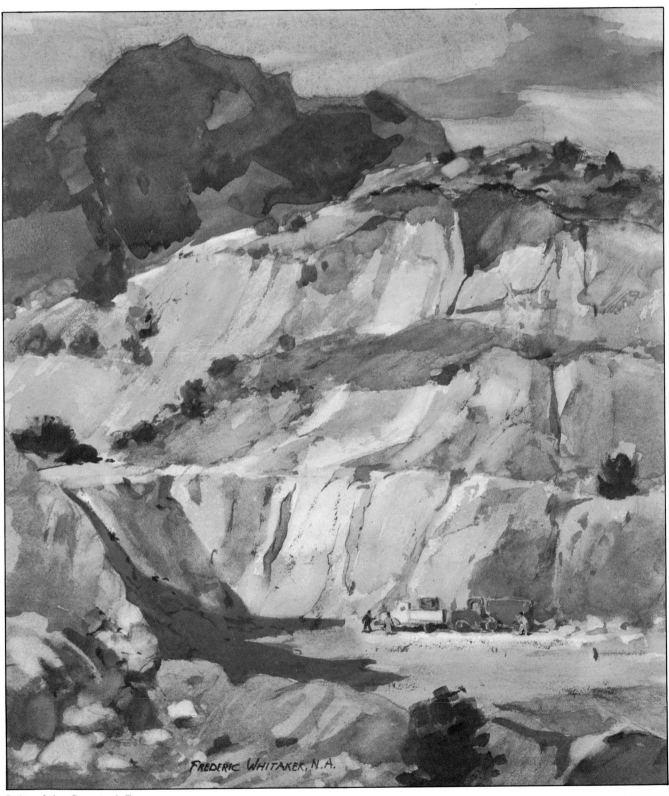

Relic of the Comstock Era
24 x 21 inches 1968

135